Collins

ROYAL
OBSERVATORY
GREENWICH

MARS

Brendan Owens

Published by Collins
An imprint of HarperCollins*Publishers*
Westerhill Road, Bishopbriggs, Glasgow G64 2QT
www.harpercollins.co.uk

HarperCollins Publishers
Macken House
39/40 Mayor Street Upper
Dublin 1
D01 C9W8
Ireland

In association with
Royal Museums Greenwich, the group name for the National Maritime Museum,
Royal Observatory Greenwich, the Queen's House and *Cutty Sark*
www.rmg.co.uk

A catalogue record for this book is available from the British Library

ISBN 978-0-00-860432-5

10 9 8 7 6 5 4 3 2 1

Printed in Italy by Rotolito

If you would like to comment on any aspect of this book, please contact us at the above address or online.
e-mail: collins.reference@harpercollins.co.uk

Contents

Introduction

Mars fascinated humans long before we even realised what it was, and before we managed to reach it with spacecraft. Ancient civilisations placed this brown-red dot in the night sky into the category of a 'wandering star', originating from the Greek phrase *aster planetes*. In comparison to the other bright points of light in the sky, it seemed to move across the weeks and months. In time, Mars and similar 'wanderers' (Mercury, Venus, Jupiter and Saturn) became known collectively as 'the planets'. For as long as humans have gazed up at the night sky, depending on the time of year and the weather, each of these planets has been visible to the naked eye.

As you'll learn from the first chapter of this book – History of Exploring Mars – its colour, interesting motion in the sky, and the way it changes in brightness has made Mars the subject of mysteries, superstitions and inspiration for thousands of years. By the time huge telescopes were being built in the 19th century, astronomers could discern features on the planet's surface that have inspired countless stories and media surrounding Martians and invaders from another world. This part of the book ends by bringing the exploration of Mars up to date with tales of robotic explorers that have flown by and around Mars, landed on it, dug into it and more.

The second chapter of this book – Mars Characteristics – is primarily a quick reference guide to the features of Mars, including a summary of our current understanding of how the planet formed and evolved. It also contains a Mars atlas to help find your way around the planet when looking at images either captured by large telescopes or from spacecraft that have reached Mars. The section concludes with a detailed look at the two moons of Mars: Phobos and Deimos.

Chapter three – How to Observe Mars – takes a deep dive into the practicalities of viewing Mars yourself, by eye, or through a telescope, or by photographing it. It describes a range of equipment entry points, as getting the best direct views of Mars can come with a steep price tag. It's important to manage expectations if taking up observing Mars as a hobby. With this in mind, in depth insights will be offered on what to expect in terms of details visible, for a variety of equipment setups, including a basic tutorial for processing a good image of Mars with a camera.

In the fourth and final chapter – You, Mars and the Future – cost-free opportunities to explore Mars are outlined. Thanks to our robotic friends past and present, there is a treasure trove of images and videos captured near and on the Red Planet which we can feast our eyes on. If you want to take things a step further, you'll find opportunities to contribute to Mars research through a number of citizen science projects. The book concludes with a speculative look at the possibilities of humans living and working on Mars and the challenges and opportunities that would entail.

So, while this book works as a whole on first reading, you are encouraged to revisit the sections as you need to. This applies whether you are interested in learning about the history of Mars exploration; or whether you want to understand the make-up of the planet, how to go outside and see it or how to dive into the rich materials collected by robots, and dream of a future where Mars might become an extension of our home on Earth.

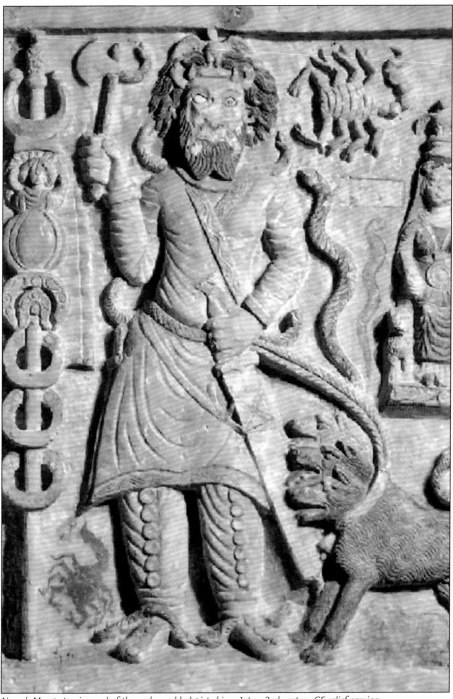

Nergal, Mesopotamian god of the underworld, depicted in a 1st or 2nd century CE relief carving.

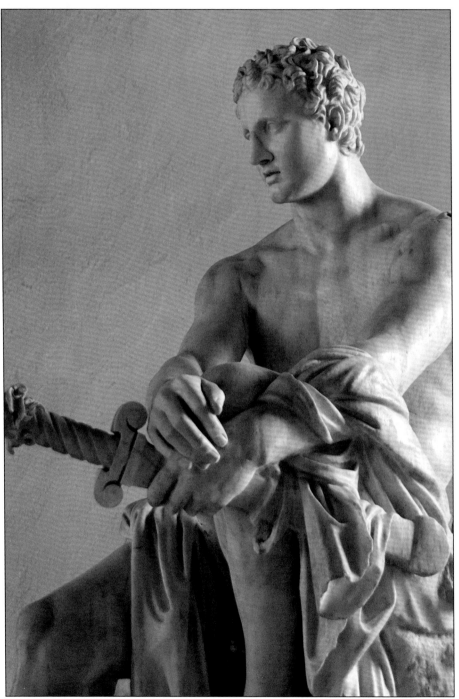

Roman copy of a Greek statue of the god of war, Ares. Crafted from marble in the 2nd century CE.

1: HISTORY OF EXPLORING MARS

Mars and Mythology

Throughout the world and thousands of years ago, stories about Mars were carved and recorded, allowing modern humans to explore and get a glimpse into what ancient civilisations thought of this particular planet. Time and time again various civilisations connected the Red Planet with war and plague and noted its strange motion in the sky over the months and years.

Looking this far into the past gives rise to some complications. Before 'science', as we know it, was established as a field of study, ancient civilisations linked the planets with different gods and goddesses. Moreover, these could be interchangeable or multi-layered. For instance, in Sumerian culture from 3500 BCE onwards, the god of the underworld, Nergal, was said to be part Sun god, but also connected to Mars and symbolised war, famine and death.

Despite occasional confusion as historians pore over ancient manuscripts, there are consistent themes that make an appearance in different ancient civilisations. Hindu art around 2000 BCE shows the god Mangala painted red, riding a chariot and carrying weapons of war. The Egyptians speak of Horus sometimes as Horus-the-red and remark that he travels backwards, in reference to the unusual motion of Mars in the sky. Roughly a millennium later the Greeks name the planet Ares after the Greek god of war. Later still, the Romans give the planet its modern namesake, Mars, who was their god of war and was considered a powerful player in the pantheon of Roman gods and goddesses.

It may come as no surprise that a bright reddish star that moves differently compared to the other planets in the sky would be seen as a bringer of war and death. We'll see that the mythological themes live on today in the modern exploration of Mars, through the names of some of its surface features and even its two moons – Phobos and Deimos (meaning 'fear' and 'terror'). These names reference the two sons of Ares that accompanied the Greek god of war into battle.

You may not have noticed that people in many countries talk about Mars every single week of the year. Tuesday originates from the Old English, 'Tiw's Day'. Tiw in turn is derived from *Tyr*, a Norse variation on a god of war. In other languages the link to the word Mars is even stronger. In the Irish language the day is *de Mairt* and in Spanish *Martes*, both of which signify 'Mars Day'. In

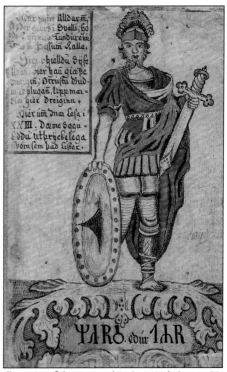

Illustration of the Norse god Tyr in an 18th Century CE Icelandic manuscript relating him to Mars.

the Gregorian calendar March is the 'month of Mars'. There's no escaping that Mars has had a significant and deep impact on cultures worldwide. We'll see another side to this influence later in this book when some of our first glimpses of Mars through a telescope were combined with wild imagination to create fantastical science-fiction stories.

Hidden amongst this tangle of terrifying tales are the references to the planet Mars travelling backwards. We will explore how this phenomenon we see from Earth actually occurs for all the planets we can see in our Solar System. This baffled early thinkers, and since the phenomenon was most noticeable with Mars, its position was recorded over time to try and understand what was going on. Eventually these records became the key to working out an accurate model of our entire Solar System that we take for granted today.

Mars in Motion

Although many civilisations did not follow a rigorous scientific method or have purely scientific reasons for studying the planets, some did work very hard to record them with as much accuracy as possible with the limited tools at their disposal.

As mentioned, at certain periods of time the planets can appear to move backwards in the sky from our perspective here on Earth. This movement is called retrograde motion, and it is an optical illusion of sorts.

The planets do not actually put the brakes on and suddenly go into reverse. We, on Earth, are overtaking the outer planets because we are closer to the Sun, and the innermost planets overtake us. Take, for example, two circular running tracks, set one inside the other with a runner on each – an outer track and an inner track. For the sake of simplicity,

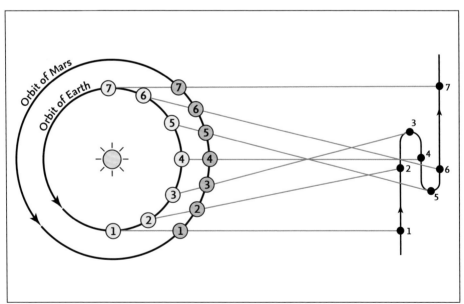

Illustration showing the perspective of an Earth observer (blue dot) looking at Mars in the night sky (red dot). On the left is a top-down view of the Solar System with seven snapshots of Earth and Mars as they orbit the Sun anticlockwise. The numbers on the right show how Mars's position changes in Earth's night sky over that time compared to the far-away background stars.

we'll assume the runners are running at the same speed. The runner on the inner track completes a lap around the track faster than the runner on the outer track. From the perspective of the runner on the outer track, the runner in the middle is zooming around the small track multiple times before they themselves make even one lap on the outer track.

The inner runner, on the other hand, notices as they loop around that the outer runner appears ahead of them, until they overtake the outer runner, at which point that outer runner goes from being ahead to being behind. Eventually, the inner runner comes back around to chasing the outer runner, who appears ahead of them. That is until, you guessed it, the outer runner slips behind as the inner runner overtakes.

Going back to the perspective of the outer runner, it's worth noting they see a similar phenomenon. The outer runner will see the inner runner briefly ahead of them before coming around from behind to overtake them all over again.

In both cases the two runners, or to leave the analogy behind – the two planets – could say from their own perspectives the other planet moves in one direction part of the time and then the opposite direction. How noticeable this change is depends on how quickly the overtaking occurs. This racetrack analogy also simplifies reality by making both the inner and outer tracks circular. Today we know that the racetracks for the planets, which we call orbits, are not circular but elliptical. The orbits of some planets like Earth are nearly circular, but Mars's path is significantly more elliptical, which makes the retrograde motion we see particularly dramatic.

But how did we get to this point of understanding about how an elliptical orbit works? Well, that's where we bring in two heavyweights of late 16th- early

17th-century astronomy – Tycho Brahe and Johannes Kepler.

As an astronomer in the century before the invention of the telescope, Tycho Brahe dedicated his life to studying objects in the night sky by eye. He wanted to prove that the old view of our Solar System, with the Earth at the centre, should give way to the Copernican view of the Solar System that has the Sun at its centre. With the support of Frederick II (King of Denmark and Norway at the time), Brahe established a new observatory on the island of Ven, Denmark. Although telescopes weren't available, Brahe could make use of a variety of instruments that could measure angles accurately and he had plenty of assistants to help him with all the calculations involved. By measuring the positions of planets and other Solar System objects as accurately as possible, repeatedly and over a long period of time, Brahe could prove (or disprove) the Copernican model of the Solar System.

Decades after starting this project, Brahe enlisted the help of a new assistant: Johannes Kepler, a German mathematician and astronomer with a passion for establishing the Copernican model of the Solar System as the definitive model to be followed. Brahe tasked Kepler with working on Mars observations and he buried himself in the endeavour. He set about using 30 years of Mars observations, gathered painstakingly by Brahe, to calculate the exact orbit of Mars around the Sun.

While other planetary observations could be analysed, Mars has some particular properties which make it a tantalising focus for study. Mars is the closest of the outer planets to us, so any changes in position are more readily noticeable compared to planets further out, like Jupiter and Saturn. Unlike Mercury and Venus, which orbit closer to the Sun, Mars is less frequently obscured by the glare of the Sun for consistent observations.

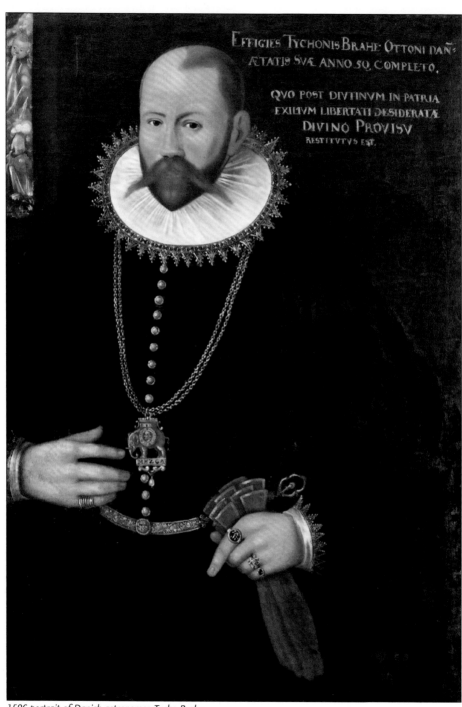

1596 portrait of Danish astronomer, Tycho Brahe.

1626 portrait of German astronomer, Johannes Kepler.

Finally, Mars's orbit around the Sun is noticeably less circular than those of the other planets.

By combining Brahe's work, Kepler's own observations and his keen mathematical skills, he was able to come up with his first two laws. The first: planets move in elliptical orbits with the Sun at one focus. And the second: a planet sweeps out the same area over a period of time anywhere in its orbit, which makes more sense in the form of a diagram, like the one seen below.

It would take another eight years for Johannes Kepler to find the right mathematical combination for his third and final law. This might be the most mathematics you'll see in this book so brace yourself and feel free to reread a few times. It goes:

The orbital period of the planet (how long it takes a planet to orbit the Sun) squared is proportional to the average distance between the planet and the Sun cubed.

Or written mathematically:

$$T^2 \propto R^3$$

[Where T is the orbital period of the planet, and R is the average planet-to-Sun distance.]

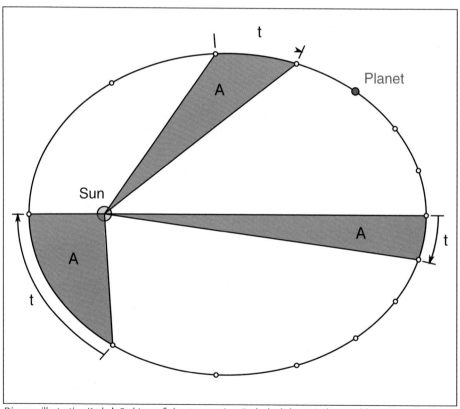

Diagram illustrating Kepler's 2nd Law of planetary motion. Each shaded part is the area (A) swept out by a planet like a radar pulse over the time (t). Although the shaded sections of the ellipse are various different shapes, the area they take up is exactly the same over the same exact period of time.

Out of the three laws, this last one acted like a Rosetta Stone for the new Solar System model. To understand how fundamental this is, we need to consider a measure of distance we don't use in everyday life – an Astronomical Unit, or AU for short. A single AU is defined as the average distance between the Earth and the Sun. If we keep the R in Kepler's Third Law in AU and the T in Earth years, we can say that 1 Earth year squared is equal to 1 AU cubed, which is true because 1 is equal to 1. If, however, we plug in how long it takes Mars to go around the Sun, you can work out how far away it is from the Sun. Thanks to Brahe's hard work and observations, we know it takes 1.88 Earth years for Mars to orbit the Sun once. Plugging this into Kepler's Third Law gives R (the average distance between Mars and the Sun) as 1.5 AU. And so it can be said that Mars is one and a half times further from the Sun than Earth is.

An accurate figure for 1 AU, the actual distance (in kilometres) between Earth and the Sun, was not found until a great deal later in history. Long before that discovery, Kepler had compiled a list of AU distances for the other known planets that were ready and waiting for that important figure. We now know 1 AU is 150 million kilometres, and so it was then a simple matter of multiplying each of Kepler's AU values by 150 million to give us the true scale of the Solar System.

Kepler's work with Mars laid the groundwork for Isaac Newton to come along 70 years later and adapt Kepler's Third Law with his new laws of gravitation. Kepler had guessed incorrectly that there was some sort of magnetic force keeping the planets in their orbits, but it was Newton who formulated the ideas we have taken as standard for gravity. Newton's adapted version of Kepler's Third Law is still used today to examine Mars, launch missions to it and land spacecraft on it.

Through the Telescope

Before we look at the period of history that features the Space Race and beyond, there is a huge chunk of time between the 17th and the very early 20th century when astronomers were still exploring Mars only with what they had on Earth.

After the painstaking observations by eye, from astronomers like Brahe and those who preceded him, the invention of the telescope at the start of the 17th century was a true game-changer.

Now the planets were no longer just steady points of light in the sky, they could be seen as small discs and, in some cases, observers could see phases like those of the Moon, but in miniature. Of course, the Moon itself gave us a tantalising glimpse of what another world could look like up close, complete with mountains and valleys.

At the start of this golden age for telescopic observations, the lenses used were only the size of a large lens you would find in a pair of glasses today, and not even to that standard. It's important to understand that the bigger the lens, the more light (and therefore visual information) the telescope can gather for your eye. Equally important is the distance the light has to travel between the first lens it enters and where it enters your eye (after passing through at least one other lens). This length, called the focal length, affects how strongly magnified or 'zoomed in' the image at the end is.

For instance, you can build a telescope that is incredibly long with a small lens at either end, and although it magnifies the image, it does not gather much light, and therefore the image tends to be blurry and unrecognisable. In fact, such a telescope was built by Johannes Kepler in later life. It was very narrow but had a focal distance of 14 metres – enormous by the standards of the time.

It would take over a century of improvements in lens-making and telescope-tube manufacturing for Mars to really come into focus, but that didn't stop early telescope users gleaning what they could from the little they had to work with.

The most famous name to arise when mentioning the telescope is Italian astronomer Galileo Galilei. It's important to remember that in the 17th century many astronomers were not creating dedicated and shared records of observation. Instead they often worked as single observers in solitude. Correspondence is our main window into the past, to give credit where it's due. There may have been others, but it was Galileo's correspondence at the end of 1610 which noted that Mars exhibits phases, and with such curves it must be a spherical body lit up by the Sun.

It would be another 40 years or so before surface characteristics were noted. Much of the credit for subsequent discoveries is owed to Christiaan Huygens and Giovanni Cassini, who were contemporaries in the mid to late 17th century. By crafting his own lenses for his telescope, in 1659 Huygens was able to make out a dark patch on Mars. Previously, other astronomers had mistaken defects in their telescopes for features on Mars. Most famously this occurred for Francesco Fontana in 1636, whose claim to fame is being the first person known to sketch Mars by telescope, complete with a dark spot in the middle and a dark ring around the edge of Mars – neither of which really existed.

However, the dark patch Huygens had sketched was a real feature on Mars, which he called the Hourglass Sea. Today it is known as Syrtis Major, derived from the Latin for the Gulf of Sidra, Libya. It was renamed Syrtis Major in the 19th century when the first properly detailed maps of Mars were created. By finding a real feature on the surface of Mars, Huygens was handed a very special gift – a way of finding out the length of a day on Mars.

On Earth we spin once on our axis every 23 hours and 56 minutes. It takes an extra four minutes for the Sun to come back to the same place in the sky as the previous day. This is because the Earth has moved a little

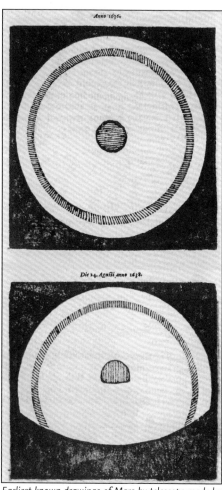

Earliest known drawings of Mars by telescope made by Italian astronomer Francesco Fontana in 1636 (top) and 1638 (bottom). The bottom image shows Mars in its gibbous phase. Neither the middle dark spot nor the dark circle exist on Mars and were instead a defect in his telescope.

Drawing of Mars by telescope made by Dutch scientist Christiaan Huygens in 1659 showing the dark region of Mars known today as Syrtis Major.

modern accepted figure of 24 hours and 37 minutes.

In that same year of 1659, Huygens used a tool for measuring small angles called a micrometer with his telescope to measure the angular size of planets. This was a key milestone in moving from positional astronomy to astrophysics; from seeing where things are in the sky to understanding what they're made of and how they work.

Cassini was not to be outdone, however, and improved on Huygens's Mars day calculation in 1666. This time the result was only 3 minutes more than the modern figure. That same year Cassini became the first person recorded to observe the polar icecaps on Mars. A few years later, Huygens observed the southern polar icecap. At this point in human history Earth's polar icecaps had yet to be discovered.

along its orbit around the Sun, so it needs to spin that little bit further for the sky to match up again to the previous day.

For Mars, Huygens recorded the time it took for Syrtis Major to go from a starting position back to that same position. By doing this several times to be sure, he calculated that the length of a Mars day is 'like that of the Earth', 24 hours. Given the tools he had to work with in the mid-17th century, it is impressive that this figure is close to the

In 1672 Cassini worked with fellow astronomer Jean Richer to measure the position of Mars from two different locations on the globe – French Guiana in South America, and France in Europe. They were using something called the parallax method to try and work out the distance to Mars.

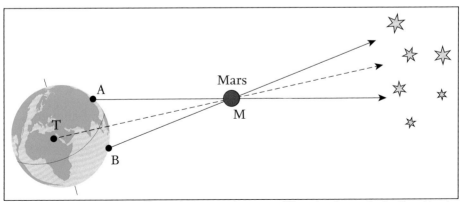

Diagram illustrating the parallax effect. In this instance observers at different locations on Earth will see Mars in slightly shifted positions in the night sky – the greater the distance from each other, the greater the difference in Mars' location compared to the background stars.

Parallax is the name given to the apparent shifting position of an object compared to a stationary background. In this case, the object is Mars, and the background is the field of distant stars behind it. In Cassini's experiment the shift is due to one observer being in France and the other in French Guiana, which gives an angle. Then knowing the separation between the two observers gives a base of a triangle, and from there some geometry knowledge can be used to work out the distance from the midway point between the observers to the object being studied.

Using this method, Cassini was able to calculate a reasonably accurate distance between Mars and Earth. That same year, prior to his appointment as the first Astronomer Royal at the Royal Observatory in Greenwich, astronomer John Flamsteed calculated a similar result without any globetrotting involved. Instead, he observed Mars at two different times and used how far the Earth had spun, instead of actually moving from one part of the Earth to another as in the case of Cassini and company.

As mentioned previously, knowing one actual distance between a planet and the Sun unlocked the true size of the known Solar System (at that time out as far as Saturn). Throwing in the angular measurements from Huygens and others unlocked another secret – the true size of Mars. Mars is 6,792 km in diameter, about half that of the Earth.

Without yet visiting Mars, the conditions on the planet could be speculated upon. English astronomer William Herschel noted through his telescope in 1784 that faint stars did not dim when seen close to Mars in the sky. This led him to speculate that Mars had a thin atmosphere, as the starlight was not being reduced in brightness by a daylit sky. Herschel also held a strong view that all the planets were inhabited and believed that the Sun had a solid surface with inhabitants, something we know today is entirely incorrect.

Herschel used his observations of the poles to estimate the tilt of Mars. Although he didn't calculate the figure we know to be true today (25.2 degrees), he came up with 30 degrees. This added fuel to the flame of imagination about Mars being inhabited, because a tilt similar to ours meant Mars could be experiencing seasonal variations similar to Earth, just twice as long because of its increased distance from the Sun.

Leaping ahead another century or so, telescopes were now powerful enough to pick out faint objects and to discover features of Mars not on the planet at all – its moons. In 1877, American astronomer Asaph Hall discovered the two moons of Mars, and it was he who named them Phobos and Deimos.

There are many tantalising Mars facts gathered from the mid-17th century onwards thanks to the telescope. Here we have a planet that is half the diameter of Earth, has polar icecaps (and possibly water), possibly has an atmosphere, experiences a day a little like Earth, has a tilt similar to our home world and even has two moons. It is unsurprising that many people of the time thought that life on Mars could be a real possibility. This situation becomes a whole lot more incredible in the centuries that follow, thanks to the changing nature of astronomical research and growing use of telecommunications.

No One Would Have Believed...

In 1877 Italian astronomer Giovanni Schiaparelli observed Mars using his 9-inch refracting telescope from Brera Observatory in Milan. Photography was still in its infancy and so Schiaparelli had to rely on sketching by hand. He drew intricate maps of Mars, giving labels to many surface features he

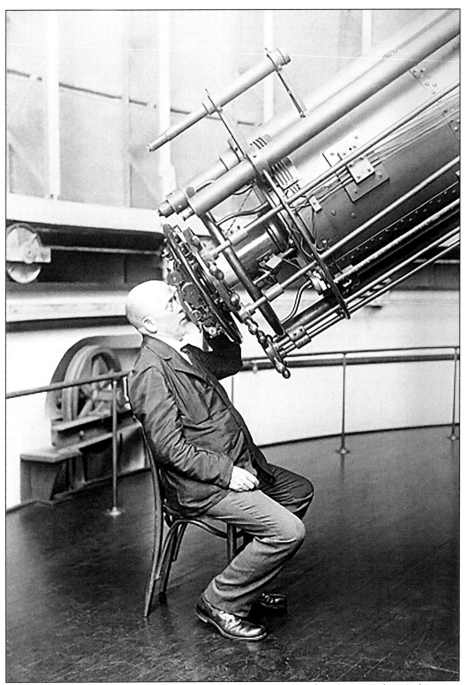

Photograph of Professor Asaph Hall, taken in the early 1900s, peering through a telescope at the United States Naval Observatory in Washington D.C.

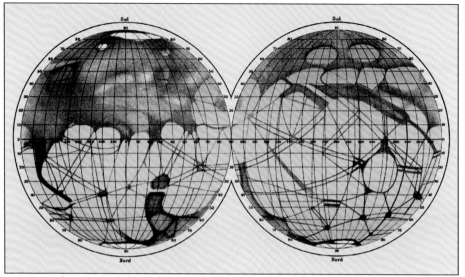

Late-nineteenth century hand-drawn global map by Giovanni Schiaparelli, here colour-enhanced. The map shows what he called 'canali' (or 'channels' in English) on Mars.

picked out, most of which we still reference today for missions to Mars. Amongst the craters and seas, he made mention of *canali*.

Copies of his works were shared and in English-speaking countries the word *canali* was translated as 'canals'. In fact, this translation has some ambiguity. While it can mean 'canals' with reference to human-made waterways, for a much longer time it simply meant 'channels', as in natural features. With the recent completion of the Suez Canal in 1869, such feats of engineering were widely known in the developed world and in terms of Mars it led to a big question. If there are canals on Mars, surely this means there is or was life on Mars to build them?

Before we leap ahead, it's worth mentioning the full tale of what unfolded is many-layered and the story has been told from different perspectives, with varying agendas and interests over the years. What follows here is a mixture of details, all of which combine to show some fantastical Mars musings, the echoes of which are still driving Mars exploration today.

Going back to Schiaparelli's hand-drawn maps, though they were incredibly detailed, he was still dealing with crude optics by modern astronomy standards. He had to contend with the limiting effects of our sky on observations. On any clear dark night, you can see twinkling stars when you look up. Some nights this twinkling is frantic, other times a little gentler. Depending on air currents, an astronomer can get a crisp, clear look at the planets, or an unusable distorted view. Even on astronomically ideal evenings, Schiaparelli would have had to contend with shimmering views of Mars.

Amongst the warping shimmers there would have been brief blink-and-you-miss-it moments of clarity. In practical terms, he would have to take his eye away from the telescope eyepiece and then quickly sketch with that fresh memory in mind until he could catch another fleeting clear glimpse, and build on the sketch bit by bit. This is still something that challenges Earth-based observers today, but we'll see later in this book how we can compensate for this blurring effect with modern digital techniques.

Although the wider astronomical community rarely mentioned observations of similar canal-like features at that time, the mystery of the *canali* reared its head again with the birth of a new, more public-facing era of astronomy and communication. Astronomers like Galileo Galilei worked in solitude and communicated by letter. However, with advancements in both printing technologies and the invention of the *telegraph*, discoveries, ideas and concepts could be spread far and wide as well as faster than ever before. Alongside these innovations came people outside the professional astronomy community, with considerable wealth and influence, combined with a deep passion for specific areas of astronomical research.

One person who really took to heart the work of investigating these so-called 'canals' on Mars was American astronomer and businessman Percival Lowell. Lowell was a keen globetrotter and documented his travels and time in Japan and Korea. His accounts range from straightforward tales of everyday life to the occult, seemingly with limited information to work from, given the language barriers. His travel-writing style may have had an influence on his future writings about Mars.

Before exploring Lowell's obsessions, let's first introduce a professional who had a profound impact on the seriousness with which Lowell took the concept of canals and, later, life on Mars. William Pickering was an astronomer operating out of Harvard University in the United States in 1887 and his older brother, Edward, was

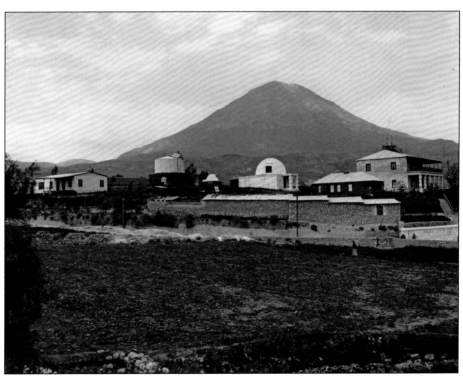

Photograph of Arequipa station in Peru, an observatory located near El Misti volcano and associated with Harvard College Observatory in the US.

Director of Harvard Observatory at that time. In 1891 Edward sent William to Peru to scope out a location for a new observatory to concentrate on creating telescopic surveys of stars. Peru was, and still is, an excellent country for astronomy research with relatively consistent high-quality sky conditions. While William did successfully locate a site in Arequipa, he went against his brother's instruction and instead focused the newly founded observatory on the planets rather than the stars, and in particular on the planet Mars.

Edward had chosen William for this adventure partly because he seems to have been favoured by the press. Edward would have been aware of the growing power of the media that influenced public perceptions and could catch the eye of future funders for astronomical research. However, William's association was a blessing and a curse. William was keen to focus on Mars in preparation for the *opposition* of 1892, when the planet would be bright in the sky and closer to Earth than usual. Despite his brother effectively firing him for not following his instructions, William was allowed to stay on in Peru for the Mars opposition event. This meant that Mars was experiencing a 'close approach' to Earth at a distance of only 56 million kilometres.

For the first time in human history, many members of the general public (including Percival Lowell) had front-row seats to the quest for proving or disproving the presence of canals on Mars. This was thanks to the ability of individuals like William to send the descriptions of their observations directly to newspaper outlets via telegraph. While communication as fast as electrical signals can travel seems like a huge boost for the speed of science communication, it came at a steep cost. In the modern connected world, we are more aware than ever of the perils of misinformation. In the 19th century these direct-to-newspaper

transmissions meant one step in the process was being missed: no one was reviewing the scientific accuracy with repeat observations and joint objective experience. Instead, every bit of information coming from William Pickering in Peru was a new adventure of the week, something that outlets knew would sell more papers.

Pickering's accounts of observing Mars were rich in detail compared to anyone else on the planet. Astronomers at Lick Observatory in California, who were opposed to sensationalism from William Pickering and his preferred newspaper partner, *The Herald* in the United States, seemed forced into a more exciting narrative around observing Mars. However, they strived to maintain scientific integrity by being a little more reserved than William and his accounts.

So the quest for Martian canals and Martians themselves became an ever-escalating series of dramatic articles, with little regard for how fantastical the stories within could or should become. Those within the wider astronomical community fought fire with fire, in some cases leading to controversy – another subject that newspaper editors knew sold copies. Astronomer Agnes Mary Clerke referred to the year 1892 as the 'Great Mars Boom' because of the overwhelming number of articles published as 'news from Mars'.

Percival Lowell was a relatively late arrival to the debate about life on Mars. In this way he was bolstered by the credibility some newspapers had given mavericks such as William Pickering. Lowell, inspired by Schiaparelli's drawings and Pickering's observations, used his wealth and William's help to found an observatory in Flagstaff, Arizona – Lowell Observatory. Construction was completed in 1894 and, over the course of 15 years, Lowell obsessed over Mars. Unlike Kepler centuries before him, this obsession went beyond science and

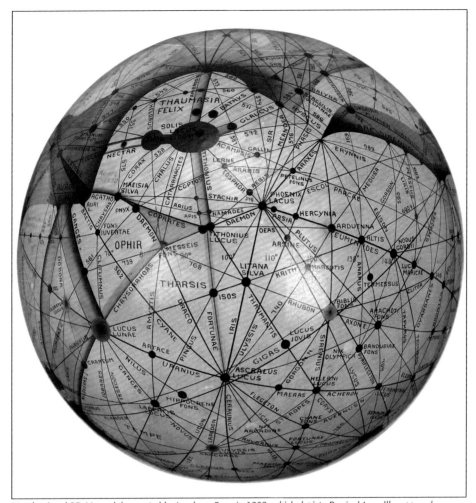

Hand-painted 3D Mars globe created by Ingeborg Brun in 1909, which depicts Percival Lowell's supposed 'canals' on Mars.

logic, and into the realm of fantasy and imagination. Lowell published three books about Mars between 1895 and 1908: *Mars, Mars and Its Canals,* and *Mars as the Abode of Life.* As is alluded to in the titles, each publication became ever more fantastical. By the time we get to his writings in *Mars as the Abode of Life,* you would easily believe he had travelled on a return voyage to the Red Planet himself and met and interviewed inhabitants before coming home to write his travelogue!

These very public debates and conversations about life on Mars created long-lasting ripples through the scientific community and popular culture. It's no coincidence that H.G. Wells published his iconic book *The War of the Worlds* in 1898, complete with a credible astronomer character called Ogilvy, and timed the events around the opposition of Mars. The title of this chapter is taken from the narrator's words in the book:

No one would have believed in the last years of the nineteenth century that this world was being watched keenly and closely by intelligences greater than man's and yet as mortal as his own; that as men busied themselves about their various concerns they were scrutinised and studied, perhaps almost as narrowly as a man with a microscope might scrutinise the transient creatures that swarm and multiply in a drop of water.

The War of the Worlds, H.G. Wells, 1898

The blurring of lines between fact and fiction created tantalisingly dramatic scenarios grounded (wrongly or rightly) in the astronomical observations of this period and beyond. Flashing forward to cinematic releases, the list of films dealing with Mars and life on Mars is lengthy, from 1950s B-movies like 1953's *Invaders from Mars* to modern blockbusters like 2000's *Mission to Mars* and 2015's *The Martian*.

Even into the 1960s, school textbooks continued to leave room for speculation about the canals on Mars. There was only one thing left to do in order to get a definitive answer: go to Mars.

Robot Explorers

The Space Race of the late 1950s and 1960s is synonymous with a race to low Earth orbit and then the Moon. By the late 1960s, the focus seemed to shift almost entirely to getting someone onto the surface of the Moon. However, this was not the only destination in mind for both the Soviet and American space agencies at that time.

Both nations also set their sights on Mars and Venus (and in one instance Mercury) for robotic missions. It made perfect sense as these are the nearest planets to our own. By far the more popular of the two targets was Mars, particularly after the Soviet *Venera* landers arrived on Venus to discover horrific surface conditions, including crushing pressure, lead-melting temperatures and acid rain. No doubt the ingrained human fascination with Mars, and the possibilities of life there, were also driving forces to get to Mars.

As the science objectives of Mars missions have grown in complexity over the years, so too has what scientists consider 'life'. While it's tempting for our minds to go straight to 'little green men' or another stereotype, life can take many forms. It's helpful to remember that in the quest to find life in the Solar System and beyond we have just one example of a planet with life so far: Earth. In science, it's generally frowned upon to have a sample size of one. That said, our knowledge of life on Earth is our only available comparison and so scientists point towards a number of common requirements for life to exist. These include but are not limited to: the presence of liquid water, protection from constant high-energy radiation and complex organic chemistry in the environment. Even with all of these in place there still isn't a guarantee of life.

Using the best available knowledge of life on our planet, planetary scientists look for biosignatures. Biosignatures can be anything (from element to phenomenon) that could point to the existence (past or present) of life in an environment. Scientists also have to contend with some red herrings with ambiguous biosignatures. Take, for instance, the presence of methane. This can be related to gas emissions from life forms like the often-referenced cow, but it can also be trapped in rocks and released through geological rather than organic means. In summary, please bear in mind that excitement at the possibility of life, or fresh biosignatures, often comes with a degree of uncertainty. This usually leads to the conclusion that more research and evidence is required.

Illustration by Henrique Alvim Corrêa of a 'Martian' featured in a 1906 Belgian edition of H.G. Wells's 'The War of the Worlds'.

Getting spacecraft to Mars, compared to the Moon, is a very risky endeavour. Depending on the trajectory of the mission, a spacecraft can take anywhere between four and eleven months to reach the Red Planet. Failures are a frequent occurrence. Some spacecraft simply fail to launch, while others can lose communication on entering the Martian atmosphere. All missions to Mars contend with risks, both known and unknown. With a delay in the sending and receiving of signals because of the vast distances involved (hundreds of millions of kilometres), many actions have to be preprogrammed into the spacecraft software. This way it can react to any planned or abnormal situations automatically, without the delay of sending a signal to Earth, someone deciding to take

an action and another signal sent back to the spacecraft to instruct it.

Away from the Earth-Moon system, spacecraft are exposed to more harmful radiation from the Sun. Also, interplanetary space is not empty. Plenty of space rocks flying by at high velocity can cause noticeable damage. And when approaching the Red Planet a spacecraft must be precisely controlled in both speed and orientation to avoid either missing the planet altogether, leaving it destined to orbit the Sun forever, or to slam hard and fast into the Martian surface.

Rather than trying to cover all successes and failures, the following profiles will pick out some famous milestone missions. Each

An early readout of Mariner 4 data coloured by hand before the digital image was processed.

one will feature what the priorities were for the mission and any key findings or historic milestones. These cover just under a quarter of the missions launched to Mars at the time of writing. The single largest period without missions to Mars falls between 1975 and 1988. Since then, a Mars mission, from a growing list of global space agencies, blasts off from Earth every three to four years.

These missions to Mars can be multi-part and include collaborations between space agencies for the different machines. For example, some missions are a combination of an orbiter (staying above in space looking down) and a rover (moving around a relatively small area of the surface) and one or the other can have more success. This means that failure is rarely totally catastrophic, and much can still be learned from a partially successful mission.

MARINER 4

Agency: NASA (USA)
Launched: 28 November 1964
Arrived at Mars: 15 July 1965

Mission Priorities: Flyby of Mars, capture images of the Martian surface, measure surface pressure and temperature as well as detect the presence of any planetary magnetic field.

Modern illustration of the 1971 Mars 3 spacecraft depicted entering Mars's orbit.

Milestones/ Key Findings: The *Mariner 3* mission failed when its protective cover became stuck after launch preventing its solar panels charging batteries. *Mariner 4* became the next best chance to capture the first glimpse of Mars on camera. It wouldn't disappoint. In July 1964 engineers and scientists waited anxiously to receive the first image transmission from this one-shot flyby of Mars. Instead of waiting for the image to be processed by computer, telecommunications staff received a 'paint by numbers' preview that they coloured in manually according to the numbers printed out. This was the first of 21 images that were eventually processed. No canals were seen, no Martian city structures. Instead, a vast area of craters and an absence of water: Moon-like. The probe also detected −100°C daytime surface temperature, a low-pressure atmosphere and no magnetic field. It didn't look likely that there was life here; however, the mission images only covered 1% of the planet's surface.

MARS 3

Agency: CCCP (USSR)
Launched: 28 May 1971
Arrived at Mars: 2 December 1971

Mission Priorities: Mars *topography*, temperature on Mars, atmosphere and surface properties, radiation and magnetic fields.

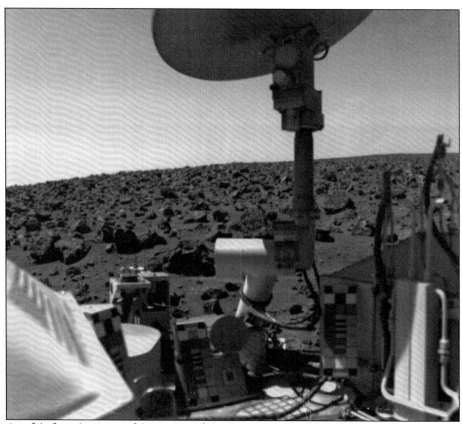

One of the first colour images of the Martian surface captured by NASA's Viking 2 *lander displaying the boulder-strewn landscape at its landing site.*

26

Milestones/ Key Findings: While *Mariner 4* was the first successful flyby, *Mars 3* was the first to include a robotic lander that completed a successful soft landing on Mars. However, only 20 seconds into its first photographic scan from the surface, contact with Earth was lost. Despite this, the orbiter section of the *Mars 3* mission successfully functioned at the planet until August the following year. Combined with the *Mars 2* orbiter, 60 images of the planet were captured, proving the value of staying above and around Mars compared to a brief flyby. Data from the spacecraft allowed temperature readings to be refined, the altitude of mountains to be measured, the thickness of the upper atmosphere to be determined and to discover that Mars has 5,000 times less water vapour in its atmosphere than Earth.

VIKING 1 AND 2
Agency: NASA (USA)
Launched: 20 August/ 9 September 1975
Arrived at Mars: 19 June/ 7 August 1976

Mission Priorities: Search for evidence of life on Mars, gather information about the structure and composition of its atmosphere and surface and capture high-resolution images from the surface.

Milestones/ Key Findings: Unlike *Mars 3* before them, the *Viking* missions were

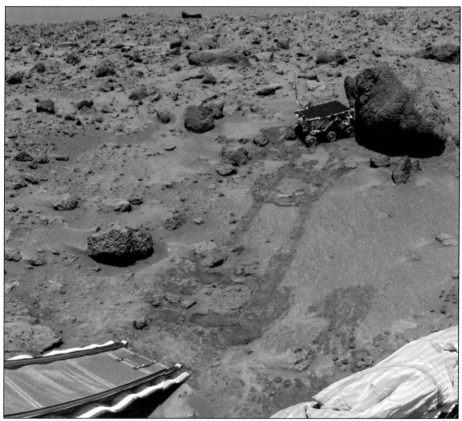

Photograph taken by the NASA Mars Pathfinder lander of its partnered Sojourner rover investigating a nearby boulder.

successful in both sets of components – orbiters and landers. In fact, they were so successful that all four spacecraft were operational for two years after arrival and one of the landers (*Viking 1*) for over six years. In that time, the two orbiters transmitted over 50,000 images of Mars and through them mapped approximately 97% of the planet's surface. The two landers were also triumphant, sending home 4,500 images of their respective landing sites. Each *Viking* lander was equipped with an arm and scoop to sample the Martian soil directly. Both landers used onboard chemical analysis instruments to try to detect signs of life in the soil. They detected weak positive results of life from a mix of samples collected, but it is thought that the *ultraviolet* radiation affected the Martian soil and gave false readings that mirrored living organisms in the soil on Earth.

MARS PATHFINDER
Agency: NASA (USA)
Launched: 4 December 1996
Arrived at Mars: 4 July 1997

Mission Priorities: Study geology on Mars, soil characteristics, study magnetic properties at the surface and gather atmospheric data. Serve as proof of concept for a new generation of innovative, low-cost technologies/ missions.

Photograph of a replica of ESA's Beagle 2 lander. Due to a failed solar panel deployment in 2003, the spacecraft was lost until it was photographed from Mars orbit in 2015.

Milestones/ Key Findings: The *Mars Pathfinder* mission consisted of a lander and a small, microwave-oven-sized rover named *Sojourner*. Unlike the landers before it, this mission showed the value of being able to choose what part of the larger landing site to investigate up-close. This was the test bed for future rover missions and the gateway to truly exploring Mars without being tied to a fixed landing site. The mission also demonstrated a new method of landing a spacecraft on Mars using a combination of parachute and airbags to bounce to its resting place. The lander featured a full *meteorology* package which gathered data about Martian dust devils, water ice clouds and daily temperature fluctuations. Images from the lander and rover also revealed pebbles that had apparently been smoothed by water erosion in the past.

MARS EXPRESS AND BEAGLE 2

Agency: ESA (EU)
Launched: 2 June 2003
Arrived at Mars: 25 December 2003

Mission Priorities: Complete high-resolution imaging of the entire Martian surface from orbit, high-resolution mapping of Martian mineralogy, study composition and dynamics of the atmosphere, determine the structure of the planet below its surface, study the effect the atmosphere has on the surface, study the interaction between the Martian atmosphere and the *solar wind*.

Milestones/ Key Findings: While the *Mars Express* orbiter is still in operation at the time of writing, two decades later, the *Beagle 2* lander was much more short-lived. Despite successful orbiter separation and atmospheric entry, no communication was received after landing on Christmas Day. It would be another 12 years before *Beagle 2* was discovered by the *Mars Reconnaissance Orbiter*. In the images from that orbiter its fate was revealed. After what appears to have been a successful landing, only two of its four solar panels unfurled, and so it could never gather enough power to phone home. Meanwhile the *Mars Express* orbiter continues to send imagery of the Martian surface. Some of its discoveries include the detection of minerals that could only be formed in the presence of water, underground water ice deposits, evidence of recent volcanic activity and an analysis of the circulation of dust in the Martian atmosphere. The orbiter also captured the most detailed images of one of Mars's two moons, Phobos, thus far.

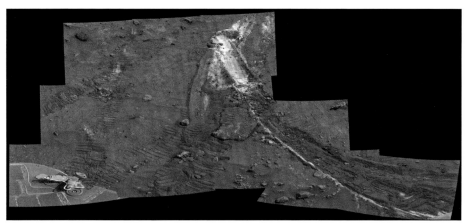

Photograph taken by NASA's Spirit rover in 2007 showing the churned-up track created by its stuck front right wheel dragging through the Martian soil.

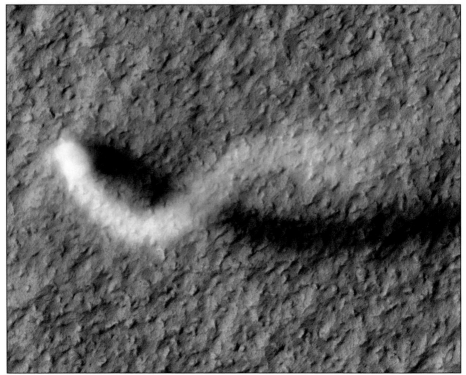

Top-down view of a dust devil on Mars captured by the High Resolution Imaging Science Experiment camera on NASA's Mars Reconnaissance Orbiter.

SPIRIT AND OPPORTUNITY

Agency: NASA (USA)
Launched: 10 June/ 8 July 2003
Arrived at Mars: 4 January/ 25 January 2004

Mission Priorities: Investigate presence of large water features past and present, study the composition and distribution of Martian rocks, soil and minerals around the two landing sites, study historic geological processes, compare readings with those taken by orbiters, search for evidence of past watery environments that could have supported life.

Milestones/ Key Findings: While *Sojourner* was a proof of concept for rovers on Mars, *Spirit* and *Opportunity* were the real deal. They were much larger and equipped with more sophisticated cameras as well as instruments for studying the chemistry of rocks up close.

Their wheel systems were also designed to flex over small obstacles and handle inclines on long journeys across the Martian surface. In its travels, *Opportunity* discovered the mineral *hematite*, typically formed in water on Earth, and veins of *gypsum*, again related to the dynamics of flowing water in the past. Meanwhile, *Spirit* uncovered rocks rich in magnesium and iron *carbonates*, providing further evidence of a wet and warm climate some time in Mars's ancient history. *Spirit* also analysed basalt rock and discovered the results of an ancient volcanic eruption. Towards the end of its operational life, *Spirit* started 'dragging' one of its wheels that had locked up. By being unexpectedly dragged

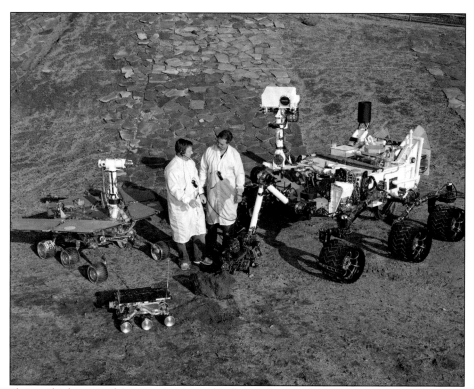

Photograph taken on Earth in a Mars training yard to illustrate the sizes of NASA's Sojourner rover, Mars Exploration rover and Curiosity rover (from smallest to largest) compared to two humans.

through the Martian soil, it dug into the top layer of the surface and onboard cameras captured images of white *silicates* beneath the planet's surface. On Earth, these are often formed in the presence of hot springs or steam vents. This provided further evidence of a past warm and wet environment that was potentially suitable for microbial life.

Both missions were designed to last just 90 days on Mars, but as they were solar-powered they had the potential for a much longer life span. In fact, *Spirit* operated until March 2010 and *Opportunity* continued transmitting until June 2018.

MARS RECONNAISSANCE ORBITER (MRO)
Agency: NASA (USA)

Launched: 12 August 2005
Arrived at Mars: 10 March 2006

Mission Priorities: Study Mars's current climate and seasonal variations, identify water-related landforms, look for any evidence of aqueous or *hydrothermal* activity, scope out future sites for landing missions and retrieving samples.

Milestones/ Key Findings: *MRO* continues to be a key eye in the sky for studying changes on Mars over long periods of time. Although the early *Mariner* missions may have given a view of a dead planet, devoid of interest, *MRO* has shown Mars to be a dynamic world with global dust storms, a water cycle, winds, frosts and shifting surface features. *MRO* also provided NASA with a veritable buffet of options for the future landing site of the

Curiosity rover (Mars Science Laboratory mission). The spacecraft has witnessed many exciting geological and atmospheric events over the years, including Martian tornados, avalanches and the formation of features from *frost evaporation*. Specifically, *MRO* captured changing spider- or tree-like features on the surface, where frozen carbon dioxide changed straight from a solid to a gas due to seasonal temperature changes. More recently in 2015, *MRO* detected large deposits of hydrated minerals, showing that liquid water is trapped in some parts of Mars. In combination with disappearing and reappearing features called '*recurring slope lineae*', *MRO* has shown that (salty) water flows on Mars seasonally.

MARS SCIENCE LABORATORY (MSL)

Agency: NASA (USA)
Launched: 26 November 2011
Arrived at Mars: 6 August 2012

Mission Priorities: Study radiation at the surface, investigate water and carbon dioxide cycles, analyse surface and near-surface geology and geochemistry, gather information on any chemical building blocks of life, look for any signs of biological processes.

Milestones/ Key Findings: Mars Science Laboratory is more commonly known by the rover that makes up the biggest part of the mission package: *Curiosity*. This rover marked a big step up from *Spirit* and *Opportunity*. Those rovers weighed 370 kg combined, while *Curiosity* comes in at a heavyweight 900 kg on its own. In this case parachutes and airbags were not going to be enough for a soft landing, so NASA created a 'sky crane' system. This was a small rocket platform that fired close to the surface to slow the rover's descent before lowering it to the surface with a cable, detaching and then flying off to crash into another part of the planet well away from the rover. *Curiosity* is like a 'lab-on-wheels' as it has the ability to scoop up soil samples and place them inside

Photograph of ISRO's Mars Orbiter Mission orbiter in 2014 before being enclosed at the top of its launch vehicle.

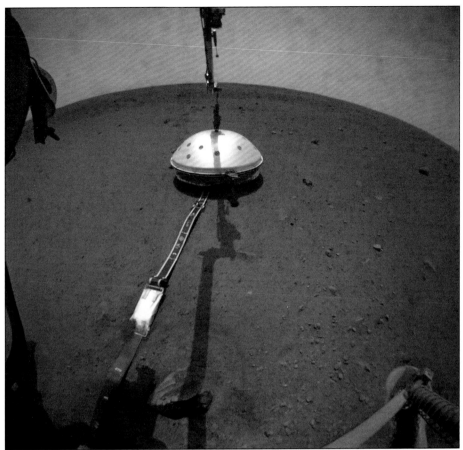

Image taken by NASA's InSight Lander as it deployed a wind and thermal shield to protect the seismometer underneath.

itself to be baked, releasing gases for chemical analysis. *Curiosity* can also use a sophisticated collection of cameras and a small laser to examine rock compositions from a distance, in order to decide what is worth investigating up-close. Unlike its predecessors, *Curiosity* does not rely on solar panels, which are susceptible to dust, thus reducing their power output. Instead *Curiosity* relies on a *radioisotope generator* that still provides power at the time of writing.

As well as being a technical marvel, *Curiosity* has further deepened our understanding of the Martian environment past and present. The rover explored rock formations that indicated a former muddy lakebed as well as accompanying rounded rocks. This was evidence to indicate that Mars had a persistent watery environment that could have lasted a million years or more. *Curiosity* provided tantalising possible evidence for life on Mars when it detected a sharp spike in methane gas over a two-month period. However, on Earth, methane gas, although potentially released by living organisms, can also be released naturally by rocks. The rover also discovered that Mars had the right set of ingredients, such as sulphur,

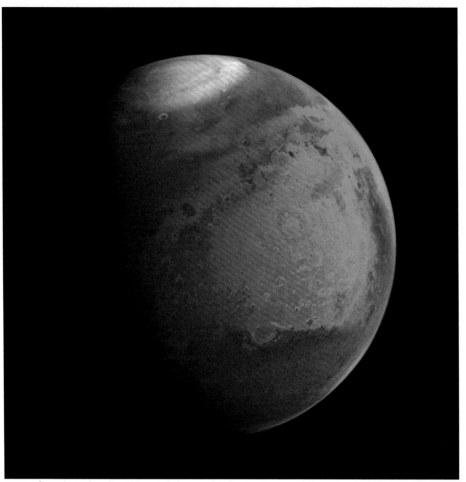

Image of Mars's northern hemisphere including north polar icecap captured in 2021 during the Martian springtime by UAESA's Hope orbiter.

nitrogen, oxygen, phosphorus and carbon, for basic life to exist when large amounts of liquid water were present on Mars millions of years ago. *Curiosity* also shed light on the mechanism for the loss of most of Mars's atmosphere in its ancient past. Through chemical analysis it showed that the loss occurred to space from the top layer of the atmosphere, which orbiting spacecraft have been able to follow up on.

MARS ORBITER MISSION (MOM)
Agency: ISRO (India)

Launched: 5 November 2013
Arrived at Mars: 24 September 2014

Mission Priorities: Study Martian surface features, rock *morphology*, mineralogy and atmosphere. Provide a proof of concept for technology and design for a sustained Mars orbiter mission from launch to orbital insertion.

Milestones/ Key Findings: Also known as *Mangalyaan* (Hindi for 'Mars Craft'), *MOM* was primarily a test bed for future missions

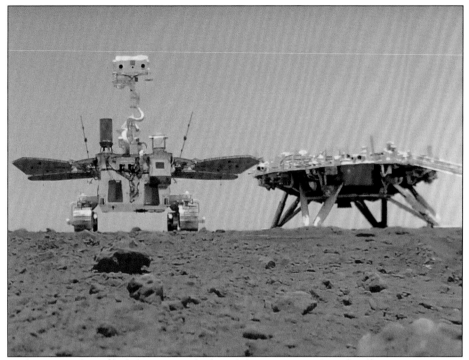

Wireless camera photo of both the Tianwen-1 lander and Zhurong rover on the surface of Mars.

to Mars from India. Given the history of failed missions to Mars, this first ISRO Mars mission was a resounding success, aside from a design flaw in its methane detector. During the mission's seven-year operation at Mars it captured images of the surface, studied the Martian atmosphere and during an Earth-Sun-Mars alignment used radio transmissions from the craft to investigate the Sun's outer atmosphere, the corona.

INSIGHT

Agency: NASA (USA)
Launched: 5 May 2018
Arrived at Mars: 26 November 2018

Mission Priorities: Understand how Mars formed and evolved over time (including its interior processes), investigate *tectonic* activity on Mars.

Milestones/ Key Findings: Unlike previous missions to Mars, the lander *InSight* had a strong focus on what lies beneath the surface of the Red Planet. Its onboard seismometer was the first to detect quakes on another planet, and measured over 1,300 of them. The lander was able to use some of the strongest 'marsquakes' to study the internal structure of the planet from thin crust to molten core. On one occasion in 2021, *InSight* was used in collaboration with *MRO* to detect a fresh deposit of water ice. By detecting vibrations caused by a large *meteoroid* impact, *InSight* helped pinpoint where *MRO* should look from above. The ice detected was churned up from the impact. *InSight* has also studied atmospheric phenomena and magnetic activity caused by the solar wind. Due to the heavy build-up of dust on the stationary lander's solar panels, contact was lost with *InSight* in late 2022 and the mission was concluded.

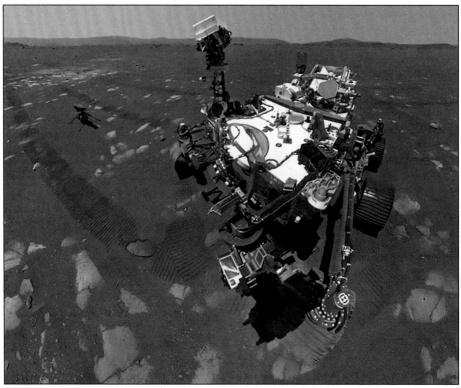

NASA's Perseverance rover takes a selfie with the Ingenuity helicopter in the background.

HOPE

Agency: UAESA (UAE)
Launched: 19 July 2020
Arrived at Mars: 9 February 2021

Mission Priorities: Study the Martian weather over time, connect contemporary weather and climate changes with the historic loss of Mars's atmosphere.

Milestones/ Key Findings: Continuing the trend of more nations worldwide engaging with space travel, *Hope* was the first mission from the United Arab Emirates to be launched to Mars and successfully put into orbit there. The orbiter has been studying the Martian atmosphere from high orbit to understand the interactions of the solar wind with the upper atmosphere of Mars. From this exceptionally elevated perspective it is hoped that the data gathered will shed light on some of the processes that have led to Mars losing its atmosphere over time, in the absence of a magnetic field. *Hope* is also ideally placed to study aurorae on Mars by working together with a similar orbiter from NASA called *MAVEN*, which is positioned in a lower orbit around the planet. Altogether *Hope* provides an unprecedented global view of the Red Planet's climate over time.

TIANWEN 1

Agency: CSNA (China)
Launched: 23 July 2020
Arrived at Mars: 10 February 2021

Mission Priorities: Study Mars topography

and geography, soil and water-ice, surface composition and interior structure, and to investigate Mars's gravitational and magnetic fields as well as its climate and general environment.

Milestones/ Key Findings: Although not the first effort made by China to launch a mission to Mars, it was the first independent mission from the Chinese space agency and a successful three-in-one project. The mission consisted of three components: an orbiter, lander and rover. All three elements were executed successfully, and China became only the second country to operate equipment on the surface of Mars. The rover, called *Zhurong*, used radar to scan for deposits of subsurface water on the planet. It also came equipped with cameras and a laser for analysing samples at a distance like *Curiosity* before it, but unlike NASA's rover it operated using solar panels. *Zhurong* finally succumbed to Mars dust in early 2023. China hopes to build on this mission's success with a future sample return mission planned before the end of the 2020s.

MARS 2020
Agency: NASA (USA)
Launched: 30 July 2020
Arrived at Mars: 18 February 2021

Mission Priorities: Analyse the processes that led to a rich geological area at and near the landing site, search for biosignatures of past life on Mars, gather numerous Mars samples potentially for return to Earth in the future, gather information relevant to future human space exploration and test technologies for human presence on Mars.

Milestones/ Key Findings: If the previous NASA Mars rover champion is anything to go by, the *Perseverance* rover on Mars 2020 is only just beginning its adventure at the time of writing. Carrying a similar payload to *Curiosity*, it is 3,700 km away from its sibling and has a small flying companion called *Ingenuity* – the first helicopter on Mars. *Perseverance* is also set apart from its sibling by being able to 'listen' to Mars as well as look at it. Equipped with two microphones, the rover enables us to hear the winds on Mars and the sounds of rocks crunching under its wheels. This not only gives us a visceral virtual visit to the Red Planet, it also has a strong scientific purpose. Take, for instance, the sound of *Perseverance*'s little rock-zapping laser. The change in the sound of the 'zap' indicates the strength and density of the rock that is being zapped.

The helicopter, *Ingenuity*, flew 72 times, giving drone-like views of the surface of Mars and the *Perseverance* rover from a maximum height of 24 metres. The operation of the helicopter is no small feat given its fragile nature and the thinner Mars atmosphere for the blades to chop through.

As can be seen by the science objectives and findings of these mission highlights, the exploration of Mars is an ever-evolving tale with discoveries building upon discoveries. Robots on Mars may have dashed hopes of canal-building Martian engineers, but excitement has built from discovering water ice on Mars, to finding past watery environments, to discovering organic compounds. Our robotic investigation of Mars is far from complete and as we'll see later in this book, our robotic pioneers are laying the foundation for future human explorers to safely visit and establish a presence on Mars. Just spare a thought for the many robotic ambassadors that failed to successfully reach or land on the Red Planet and the teams of brilliant scientists and engineers who worked long and hard to pursue their dreams.

2: MARS CHARACTERISTICS

From the observations made by early astronomers, to todays images produced by the latest robotic explorers, our view of Mars has evolved to include accurate measurements of its main physical characteristics. This includes the brilliantly detailed maps from a slew of Mars orbiters that build on the work of 19th-century Mars cartographers like Schiaparelli. Contemporary Mars atlases are detailed enough to identify major features such as mountains, craters and canyons.

An understanding of Mars would not be complete without exploring its two moons, Phobos and Deimos. They too have been studied in detail by spacecraft to understand their physical characteristics and even gain insight into what will happen to them tens of thousands of years from now.

However, not all our knowledge regarding the physical characteristics of Mars is so clearly established. The long-term history of Mars is a complex tale that is yet to be fully unravelled. We will delve into the ideas put forward for how Mars has changed dramatically over the course of its 4.6-billion-year lifetime, particularly the loss of vast amounts of liquid water from its surface.

Mars in Numbers

Presented here are facts and figures for various aspects of Mars, including how big it is, what it's like on the surface, how it orbits the Sun and figures relevant to viewing Mars from Earth.

Mars is orbited by its two moons, Phobos and Deimos, which we'll discuss later. Mars is half our planet's width, with only 11% of Earth's mass and 71% of its density. If Earth was entirely hollow, we could fit nearly seven of Mars inside it. The planet has roughly the same surface area as all the dry parts of Earth. Unlike the solid core of our home world, Mars has a suspected all-liquid core, and therefore is less geologically active. Also, without a spinning core, Mars has

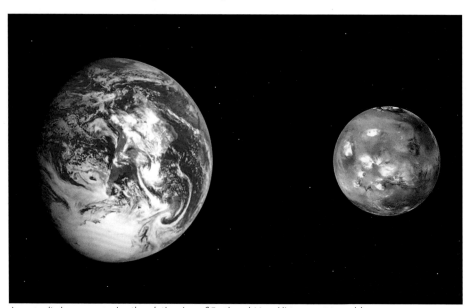

A composite image comparing the relative sizes of Earth and Mars (distance not to scale).

no global magnetic field. Earth's magnetic field is incredibly important in protecting us from harmful *cosmic radiation*.

Moons: 2
Diameter: 6,792 km
Surface area: 144 million square km
Mass: 6.4×10^{23} kilograms
Density: $3.93 g/cm^3$

Mars has 38% the gravity of our planet and parts of the Red Planet can get down to a bitterly cold −133°C, or up to a pleasantly warm 27°C at its equator in the Martian summertime. Mars has a significantly thinner atmosphere than Earth and therefore cannot trap the heat of the Sun the way our thicker and denser atmosphere does. Mars has a weather system that includes winds, dust storms and snow. Though the planet is not very Earth-like in appearance or surface conditions, there are two cosmic coincidences. Not only does a Mars day last only a little longer than an Earth day, but Mars is also tilted just a little more than Earth. This gives rise to a similar pattern of seasons, with the key difference that Mars's

larger orbit means they last twice as long. However, with a thin atmosphere almost entirely composed of carbon dioxide and intense solar radiation on the surface, there is no chance of any trees developing buds, becoming lush with foliage and turning an autumnal gold.

Gravity: 3.73 metres per second squared
Temperature range: −133°C to 27°C
Axial tilt: 25.2 degrees
Gases in atmosphere: carbon dioxide (96%), argon (less than 2%), nitrogen (less than 2%)

Mars has a more elliptical orbit than the other planets in our Solar System. This means there is a great difference between the planet's closest approach to the Sun and its furthest distance. The time it takes for the planet to rotate on its axis once, plus three more minutes to account for the small distance travelled by the whole planet in its orbit over that time, represents one day. To differentiate between an Earth day and a Mars day, one day on Mars is known as a sol. A sol is 40 minutes longer than a day on Earth.

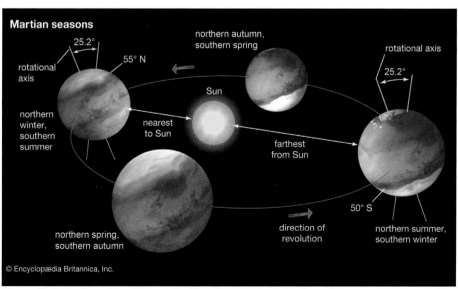

Diagram illustrating the position of Mars and its tilt relative to the Sun for Martian spring, summer, autumn and winter.

Rotation period: 24 hrs 37 mins
Length of a Mars day (1 sol): 24 hrs 40 mins
Orbital period: 1.88 years

Average orbital distance: 227,940,000 km
Farthest orbital distance: 249,261,000 km
Closest orbital distance: 206,650,000 km

For observers on Earth, Mars can appear significantly brighter or significantly dimmer depending on its distance from Earth, and whether it is in a full phase or a gibbous phase. The latter is when most, but not all, of the planet is illuminated by the Sun. Mars can appear so bright in the sky that it can outshine the bright gas giant Jupiter. When we speak of brightness in astronomy, we use the term visual magnitude. The larger the positive number, the fainter the object appears. Very bright objects are listed with negative magnitudes. For reference, our Sun has a visual magnitude of –27 and the bright star Vega in the constellation Lyra has a visual magnitude of 0.

Although the numbers in the next column show that Mars can be nearly 350 million kilometres closer to Earth than when it is at its furthest distance, its size does not appear dramatically different in the sky to the eye. Even at its closest to Earth, Mars is only one seventieth the width of the Full Moon in the sky. It might help to remember that, at that distance, the Moon is still over 100 times closer to us than Mars. Once in a while, a Mars hoax diagram appears on the internet claiming that Mars will appear as big as the Full Moon in the sky, but now you know that could never be the case.

Maximum distance from Earth:
401,400,000 km
Minimum distance from Earth:
54,600,000 km
Visual magnitude range: +1.86 to –2.94

Space agencies have had a dramatic history with Mars. Approximately half the missions sent to Mars thus far have failed in some way. It is worth considering the length of time it takes signals to be sent to and delivered from Mars, which makes controlling and monitoring Mars spacecraft nerve-racking for engineers back on Earth.

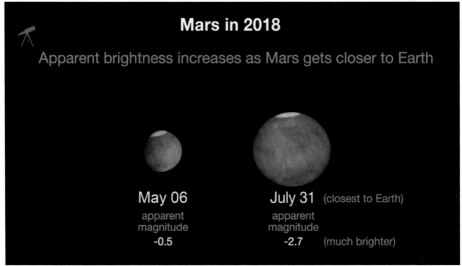

Mars in 2018

Apparent brightness increases as Mars gets closer to Earth

May 06
apparent magnitude
-0.5

July 31 (closest to Earth)
apparent magnitude
-2.7 (much brighter)

Diagram comparing the size of Mars between May and July 2018. A close approach of Mars can offer significantly better detail when viewed through a telescope.

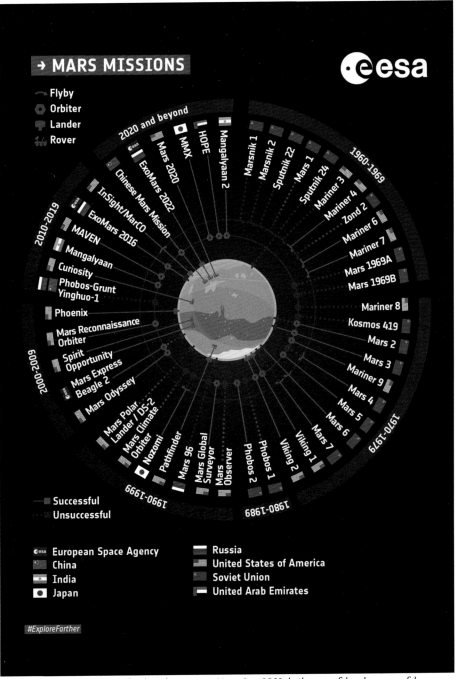

Diagram showing all missions that have been sent to Mars since 1960, both successful and unsuccessful. The diagram also features the yet to launch (at time of print) ISRO Mangalyaan 2 and MMX missions.

On the treacherous entry into the Martian atmosphere, landers or rovers will already have experienced their fates well before the success or failure signal is received back at Mission Control on Earth. It also means that many spacecraft functions have to happen in sequence without human intervention. Carefully laid contingency plans must be in place for numerous situations, with programming suitable to change to plan B, C or D accordingly and automatically.

Missions to Mars: 49 (as of September 2024)
Light travel time to/from Earth: 3 light minutes (at minimum distance), 22.3 light minutes (at maximum distance)

Evolution of Mars

Our human history of observing Mars may go back thousands of years, but the history of Mars itself spans 4.6 billion years. At the dawn of our Solar System, a cloud of gas and dust from the violent death of a previous-generation star started to collapse under the force of gravity. While collapsing, this mass of gas and dust spun faster, like an ice skater bringing their arms in while spinning. With the collapse came higher pressure and higher temperatures, with the majority of gas and dust collapsing to form our star, the Sun. This early, relatively flat, swirling baby Solar System is often called a protoplanetary disc and it resembles a cosmic Frisbee. We have pieced this image together from the physics involved, but astronomers have also seen these discs using NASA's Hubble Space Telescope in other regions of space, including the Great Orion Nebula.

In the recipe for the Solar System we know today, the first steps are still somewhat

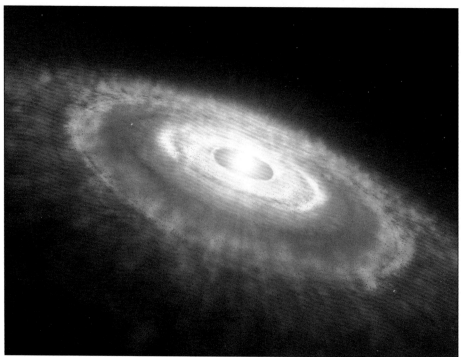

Concept art of a protoplanetary disc – the term for the swirling disc of dust and gas surrounding a newborn star that eventually coalesces to form a stable planetary system like our own Solar System.

uncertain. There are a number of hypotheses for the formation of the planets – both rocky and gaseous. Most involve rock and metal sticking and clumping together to form planetesimals, which are mini planets of sorts.

However, Mars proves to be a conundrum in some computer models of the formation of our Solar System. In those simulations, and for that region of the protoplanetary disc, Mars should work out to be somewhere between 50% and 100% the mass of Earth. However, today we know it's only a paltry 11% of Earth's mass. In order to solve this mystery some astronomers subscribe to the 'Grand Tack' hypothesis. This idea suggests that the gas giant Jupiter didn't stay in the same region of space early in the history of our Solar System. Instead, it's proposed that it migrated closer to the Sun before being gravitationally kicked back out again into the further orbit it now travels along. On its way out, giant Jupiter robbed baby Mars of the mass it could have used to grow to the healthy mass of Earth or Venus, the latter of which is still 80% of Earth's mass.

There are a number of other possibilities for why Mars is an anomaly in this regard. It has been suggested that material could have fallen inwards towards the Sun faster than the formation of the embryo of Mars. Alternatively, some other planet movements could have again stripped the region of a substantial amount of the building blocks for the planet. Or it might be the case that the mass was simply not evenly distributed, and Mars started to form in a relatively sparse part of the protoplanetary disc.

Through our robotic explorers on and around Mars, geologists on Earth have been able to piece together some fundamentals about the structure of the planet. Starting from the inside and working our way out, Mars has a liquid iron core surrounded by a layer of soft molten silicon-rich rock, which

in turn is surrounded by a rocky mantle and a relatively thick crust compared to Earth. From seismic readings taken by NASA's *Insight* lander, estimates for the core's size are around 3,600 kilometres wide, or about half the width of Mars.

According to this data, Mars differs from Earth, which has a solid metal core surrounded by a liquid metal lower mantle. Earth's solid core spins in this liquid metal layer and generates our global magnetic field. In contrast, no global magnetic field has been detected on Mars, which makes sense, given the internal structure as we understand it. However, rocks in the southern hemisphere of Mars are highly magnetised, suggesting that a magnetic field did exist on Mars at some point in its ancient past. There is still debate over how long a global magnetic field lasted on Mars, and how it worked without the same internal mechanisms at play that we have on Earth. While orbiters have been able to study Mars rock magnetism millions of kilometres from Earth, no samples of Mars rock have been brought back from the Red Planet yet. However, a famous space rock that landed on Earth has given us a new estimate for how far back Mars's magnetic field goes.

The space rock, or *meteorite*, in question is Allan Hills 84001 (ALH84001), named after the location in Antarctica where it was discovered in 1984. The meteorite is estimated to have arrived on Earth 13,000 years ago. By comparing the gases trapped within it with the known composition of Mars's atmosphere, scientists were able to match them and show that it originated from the Red Planet. Around 120 such Martian meteorites have been discovered on Earth. Using the *radioactive decay* of certain elements can help us understand how old these Mars rocks are. Before dating the magnetic field logged in the meteorite, this voyager from another world was famous for

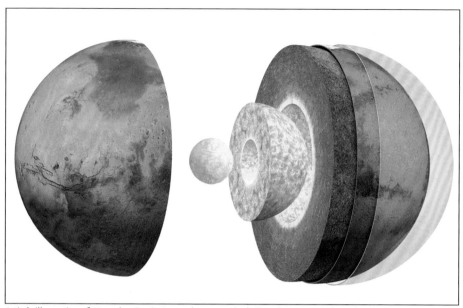

Artist's illustration of Mars showing its internal structure including the core, mantle and crust.

a far more exciting reason: the possibility of fossilised alien microbes.

ALH84001 was studied using a scanning electron microscope, which revealed shapes that looked like mini fossilised bacteria. This was later disproved but did cause quite a stir in the media. In 2022 another group of scientists used a sophisticated *quantum microscope* to read a magnetic field that dates back 3.9 billion years. This suggests that Mars had a strong global magnetic field that lasted hundreds of millions of years.

Landing on Mars, we come to the surface level where today we see the results of previous volcanic activity, erosion and old asteroid impacts. The Martian landscape can vary radically and is far from a homogeneous red orb sparsely littered with rocks. It is home to mountains, valleys, cliffs, caves, basins and more.

Ancient volcanic activity on Mars gave rise to colossal, and now extinct, volcanoes like Olympus Mons and Elysium Mons.

These vastly outclass our mountains on Earth in scale. Olympus Mons towers over 20 kilometres above the Martian surface – in other words, it's two and a half times taller than Earth's Mount Everest. These improbably tall mountains are the result of two main differences in the make-up of the planet compared to Earth. Firstly, Mars has no plate-tectonic activity. On Earth *magma* from beneath the crust erupts up and out, resulting in a chain of volcanic features as the plates move. On Mars the magma was pumped up consistently into the same surface region over and over. This resulted in a much greater build-up of lava in the same location. Secondly, due to its lesser mass, Mars has weaker gravity and these peaks were able to reach much greater heights compared to peaks on Earth. The surface of Mars contains other elaborate and mesmerising volcanic features such as lava tubes and lava flows.

Mars is littered with craters of various sizes that are the result of asteroid impacts millions, and in some cases billions, of years

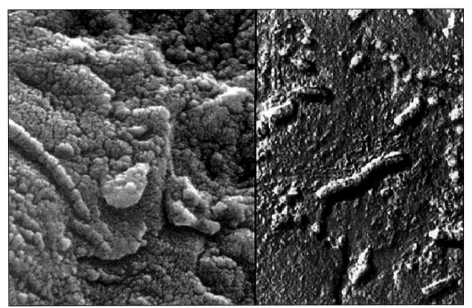

Scans of a section of Mars meteorite ALH84001 taken with a scanning electron microscope that appeared to show 'bacteria-like' features, later disproved.

ago. How many there are and their spread in any given region allows planetary scientists to roughly estimate the age of different parts of the surface.

Thanks to the study of cratered regions like these and surface features related to different types of erosion, geologists on Earth have been able to categorise the various geological ages of Mars into Pre-Noachian, Noachian, Hesperian and Amazonian eras. The Pre-Noachian period is murky. It marks the time between the planet fully forming and the end of the regular large impacts on the surface. This period is estimated to cover 4.5 billion to 4.1 billion years ago. During this time Mars seems to have suffered an enormous impact that caused an expansive depression across the northern surface of the planet, creating a world of two halves. The northern hemisphere is relatively low-level, with very few dominant features visible today, due to more recent volcanic activity. In contrast, the southern hemisphere contains highlands and much richer visible geological surface features. The mammoth impact in the northern hemisphere would have driven a lot of rapid climate change in Mars's early atmosphere. Under the heat and high pressure, water vapour would have been released from the mantle that eventually condensed to form oceans. These oceans would have been boiling hot and would have only cooled much later. As evidenced by the ALH84001 meteorite, Mars had a global magnetic field in place during this period.

The Noachian period that followed lasted approximately 400 million years and marked a time of great volcanic activity alongside continued regular (though less massive) impacts. These processes produced some of the most iconic features that are still visible on Mars today. The Tharsis region of Mars erupted with vast volcanoes, pumping ash and dust into the atmosphere. This led to a wet warm environment that some

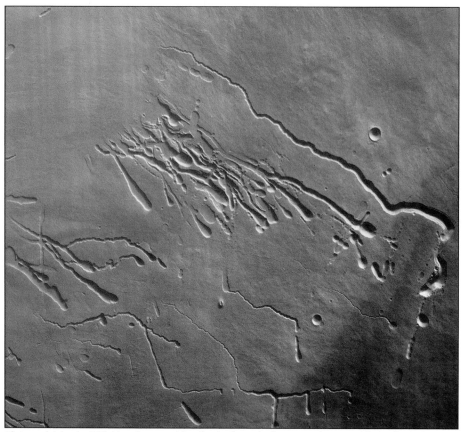

Photograph taken by ESA's Mars Express orbiter showing lava tube features on the western slopes of Pavonis Mons.

planetary scientists think created enough liquid water to fill the lowlands in the north to make an ocean. During this time, while the atmosphere remained thick and a global magnetic field was in place, there may have been an opportunity for basic forms of life to develop, but no evidence of this has been gathered to date. Such was the ferocity of the ongoing eruptions in the Tharsis region that a vast swathe of nearby surface was torn apart, creating the Valles Marineris. This canyon spans the width of North America and, at its deepest, plummets seven kilometres.

The decline of the magnetic field on Mars takes place in the latter part of this era as the planet's core continued to cool and solidify. Eventually, without this protective magnetic field, the Martian atmosphere was susceptible to being stripped by the solar wind. With this thinning atmosphere came a reduction in the amount of heat that could be trapped around the planet. While Mars had liquid masses of water (something we consider a prerequisite for life), an atmosphere protects that life on the surface from being bombarded by harmful radiation and high-energy cosmic rays. If basic forms of life did have a chance to develop earlier in the planet's history, they would not have survived without this protective layer (at least not on the surface and using the biological properties of Earth life forms as a baseline).

The Hesperian period lasted from 3.7 to 2.9 billion years ago and was marked by significant climate change. The lack of magnetic field and the thinning atmosphere caused the planet's global temperature to reduce significantly. Countering this, volcanic activity continued, though at a reduced rate. Eruptions threw out enough sulphur dioxide gas to initiate acid rainstorms, which eroded surrounding regions.

In this era any water present was quickly cooled to ice, rather than existing as liquid.

Although Mars did not suffer large impacts regularly in this period, those that did occur pulverised rock, rapidly heating any ice to trigger short-lived localised flash flooding.

Finally, the Amazonian period from 2.9 billion years ago to the present day marked a transition from a dynamic planet to the more barren and inactive one we are familiar with today. Events both volcanic and impact-based were much reduced and the atmosphere was depleted to a very thin layer wrapped around the planet. As volcanic activity declined and

Artist's impression of what Mars may have looked like around four billion years ago, when the climate was warm enough to sustain a huge ocean in lower-lying regions in the northern hemisphere of the planet.

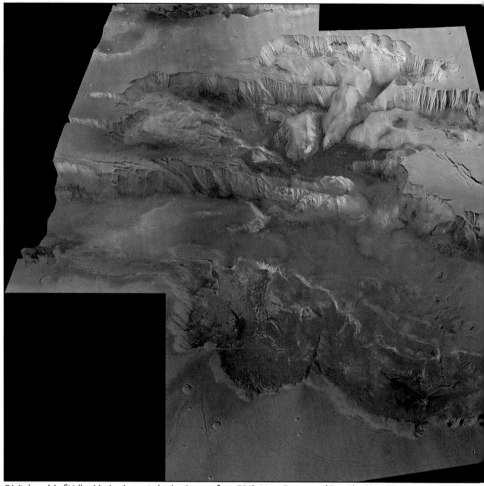

Digital model of Valles Marineris created using images from ESA's Mars Express orbiter. The 630,000-square-kilometre feature is seen here at a 45-degree angle with its height exaggerated by 400%.

reached its end, the last sputters of volcanic activity produced outflows of lava that filled and smoothed out the lowlands, particularly in the northern hemisphere. After billions of years of impacts, eruptions and floods that moulded and remoulded the surface of Mars, the planet is now gently sculpted by its winds, the dust storms they carry, frost evaporation and seasonal condensing of vapour in the atmosphere. Those forms of erosion have worn away many older features,

making the detective work required of planetary scientists to map out the natural chronology of Mars difficult.

While the ancient oceans of Mars are long gone, water does still exist on the planet and is seasonally transported. The north polar region contains a body of water ice with a volume similar to Earth's Mediterranean Sea, under a layer of frozen carbon dioxide. During the northern hemisphere summer,

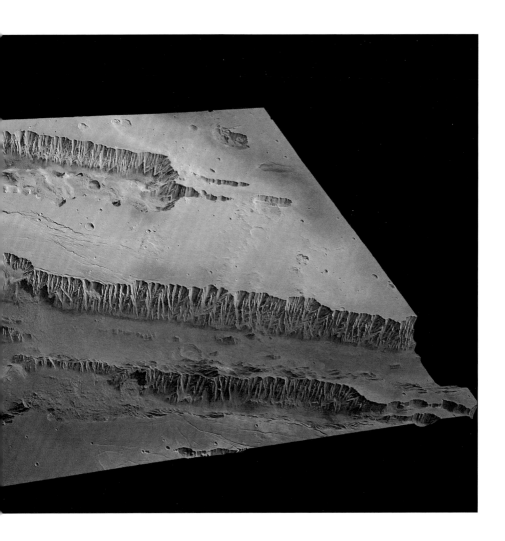

the carbon dioxide ice sublimates. This means it turns directly from a solid to a gas. People often see this at festivals and concerts, and it's commonly known as 'dry ice'. This *sublimation* also happens in other regions of Mars, but on a smaller scale, resulting in frost evaporation features that seasonally expose older darker rock that has been hidden under the ice. Mars rovers and landers have detected ice that can persist just below the surface, but once exposed (for instance, by a rover wheel or robotic scoop), the ice sublimates under exposure to sunlight.

Coming back to the water cycle, the water ice, now free of its carbon dioxide cap, is also able to sublimate and the resulting water vapour enters the atmosphere. Here it meets dust storms, which alter the thermal properties of their vicinity. Depending on the amount of dust and sunlight, the water vapour can be transported to other regions

Ice deposits and stratification at the Martian north pole including seasonal dust clouds seen as plumes just above the surface.

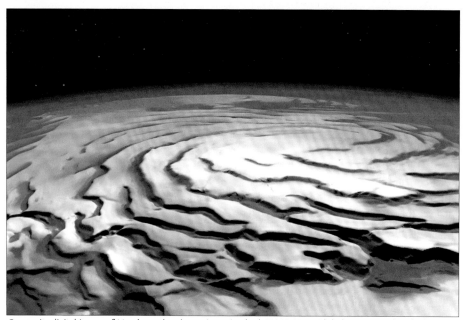

Composite digital image of Mars's north polar region using both NASA Mars Global Surveyor altitude data and ESA Mars Express imagery.

of Mars where it condenses on other parts of the planet.

The Martian water cycle is not the only significant seasonal variation on the Red Planet. In 2004, the European Space Agency's *Mars Express* orbiter detected the chemical signature of methane in the trace gases of the atmosphere. While only found in ten parts per billion of the atmosphere, it raised the question – where did this methane gas come from? On Earth, methane can be produced in the natural process of releasing gas, as experienced by humans and other life forms all the way down to microbes. This left scientists excited about life on Mars once more, but methane emissions on Earth have been shown to be produced by non-biological processes too, such as in *inert* chemical reactions and methane that is trapped in rocks and later released.

The mystery deepened after NASA's *Curiosity* rover recorded seasonal fluctuations in the amount of methane present in the atmosphere over three years (2012–15). Sometimes the reading from its Sample Analysis at Mars instrument (SAM) rose to 60 parts per billion. This methane outgassing remains unexplained and there have been disagreements between measurements taken from the surface and those taken from orbit by other spacecraft. It appears that rovers experience a build-up of methane around them at night, but during the day the warmth of the Sun causes it to be mixed with the rest of the atmosphere and remain barely detectable or completely undetectable.

Mars Atlas

On the following pages you will find some of the most prominent surface features of Mars. Not all are visible from Earth, but they are clearly visible in the photography captured by the robotic sentinels observing Mars high above its surface.

Mars is a world of two halves, with a smoother top compared to its elevated and heavily cratered bottom. The southern hemisphere of Mars, while elevated, features some truly enormous depressions called basins, such as Hellas Basin and Argyre Basin. Mars has two prominent polar icecaps that can be viewed through a modest telescope on Earth under the right conditions. Across all of Mars, planetary scientists have estimated there are over 43,000 craters that are three kilometres or wider.

Given the many features on Mars, ranging from minor to major, it would be impossible to include them all here. Therefore ten features (in no particular order) will be discussed. Before we delve into them, the images on the following page will give a whole planet view and mark their locations. The first map is in 'real colour' and, apart from being a flattened image of Mars, it should look familiar. This map, however, doesn't give a true sense of the different surface terrains and so it is followed by a global 'false colour' map. In this map, grey-white areas mark the highest peaks, and the deep violet areas mark the lowest depressions.

POLAR CAPS

The Martian polar icecaps consist of a layer of frozen carbon dioxide on top, and water ice below. The carbon dioxide comes from the atmosphere of Mars and in winter the temperatures are low enough at the pole for the carbon dioxide gas to condense into a layer of ice. Whenever either pole is tilted towards the Sun for their respective summer season, the frozen carbon dioxide sublimates.

The northern polar icecap of Mars is the larger of the two, measuring 1,000 kilometres across on average. The southern polar icecap is less than half the diameter, at an average of 400 kilometres wide.

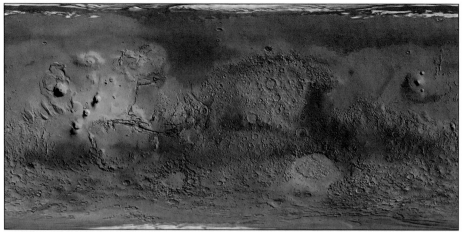

'True colour' flattened image of the entire surface of Mars. Complements the false colour image below.

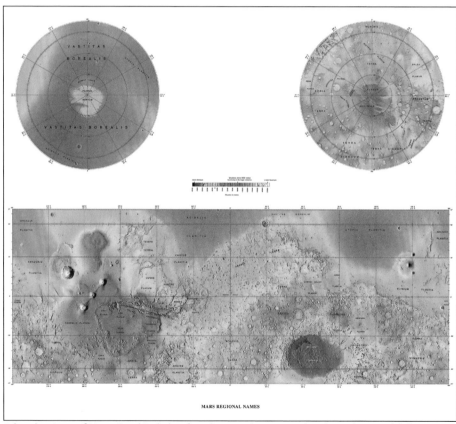

False colour image of Mars using altitude data from the MOLA instrument onboard NASA's Mars Global Surveyor. Areas that are red to white indicate the highest elevations, while blue to purple show the lowest-lying depressions.

Both exhibit a spiral pattern due to long-term wind erosion that created canyons two kilometres deep, equivalent to two of Dubai's Burj Khalifa towers stacked one on top of the other.

OLYMPUS MONS

Olympus Mons currently holds the title of largest known mountain in the Solar System. It rises 25 kilometres above the planet's surface and is far wider than a typical mountain or volcano on Earth, spanning nearly 600 kilometres across. If you were to attempt a hike up Olympus Mons, the first six kilometres would feature a steep incline of over thirty degrees. After climbing the equivalent of two of Greece's Mount Olympus in height, the hike to the summit would be more gently sloping at just five degrees. Even so, it would take days to traverse the remaining 250 kilometres or so to the edge of the *caldera*. Finally, to reach the centre of Olympus Mons from above, you would have to abseil down into the caldera and take the last, mostly flat, 30 kilometre journey to its centre.

Olympus Mons is classified as an extinct *shield volcano*, meaning it no longer shows signs of any volcanic activity. It developed its shield-like appearance through the eruptions that took place over the same region of Mars billions of years ago, leading to a large accumulation of lava that cooled and formed the wide base of this surface feature. Its most recent eruption is estimated to have been 25 million years ago. However, marsquakes have been detected by NASA's *Insight* lander in other regions, so future eruptions are not completely out of the question.

VALLES MARINERIS

Often referred to as the 'Grand Canyon of Mars', the title does not do this vast gorge justice. Stretching 4,000 kilometres, this valley is roughly ten times the length of the United States' Grand Canyon. At its deepest, the Valles Marineris is also five times deeper than its counterpart on Earth. Its width, at over 200 kilometres, is roughly two thirds that of Ireland. So vast is the scale of Valles Marineris that mapped to Earth, it would just about fit into the landmass of North America.

The Valles Marineris was likely born of a series of ruptures as a result of the large amount of volcanic activity that took place millions of years ago in the Tharsis region, which includes Olympus Mons. Its current state is the result of these repeated ruptures combined with later periods of water erosion, which deepened it, and landslide events that further shaped the valley edges.

HELLAS BASIN

This feature is one of the largest impact basins in the entire Solar System. It is a depression approximately 2,300 kilometres wide and up to nine kilometres in depth. If someone was standing a few hundred kilometres away from the edge of Hellas, a mountain the size of Mount Everest could be hiding inside, and you wouldn't know until you moved closer and looked down into it. The basin is the result of the largest confirmed impact Mars ever experienced, most likely an asteroid, over 100 kilometres wide, that struck the planet between 3.8 and 4.1 billion years ago.

Due to the extreme depth of the basin, the atmospheric pressure at its deepest point is almost 90% greater than the pressure at the average elevation of Mars. This means that water could exist here as liquid. Elsewhere it has been mentioned how water on Mars is usually in the form of ice and, due to the low atmospheric pressure, the ice sublimates directly from ice to vapour. However, the total amount of ice in Hellas Basin (water or carbon dioxide) has not been determined, and much of it could remain hidden as glaciers beneath layers of dust.

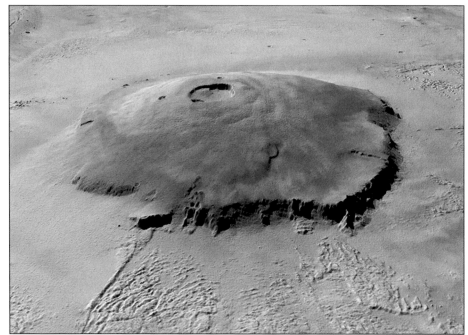

Greyscale composite image of Olympus Mons using altitude data and imagery from NASA's Mars Global Surveyor.

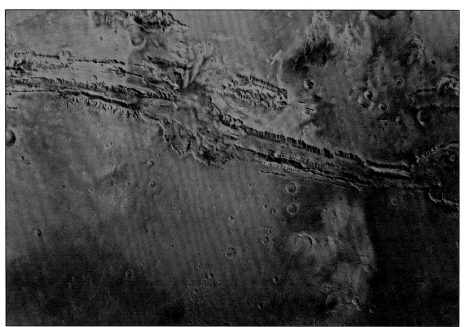

Colourised mosaic of images from NASA's Viking 1 and 2 orbiters capturing the full 4,000-kilometre-wide extent of the Valles Marineris (or Mariner Valley).

Even though orbiters can view the basin from above, it is often obscured by dust storms swirling inside the crater. On the rare occasion that the view has been clear, the basin floor can be seen to contain a small number of large craters, each tens of kilometres wide, and the edges of the basin are staggered in terraces shaped by wind erosion.

SYRTIS MAJOR

This volcanic feature can be seen as a large dark smudge on Mars through a modestly sized telescope on Earth. It was the first Martian surface feature ever identified (by Christiaan Huygens, 1659). It may not appear as obvious as the mighty Olympus Mons, but Syrtis Major is also a shield volcano – though it is much shorter and wider. Standing just two kilometres high, but over 1,000 kilometres wide, it is gently sloping and has two calderas (the collapsed mouth of a volcano) called Nili Patera and Meroe Patera at its peak.

Syrtis Major is a point of curiosity for planetary geologists as it contains concentrations of granite and *dacite*, which are common on Earth but very rare on Mars. This points to

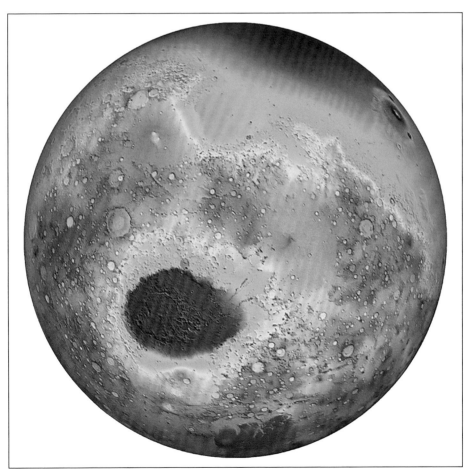

The large purple area in the lower left of this false colour image depicts Hellas Basin, a deep and wide crater created by a massive impact in Mars's ancient past.

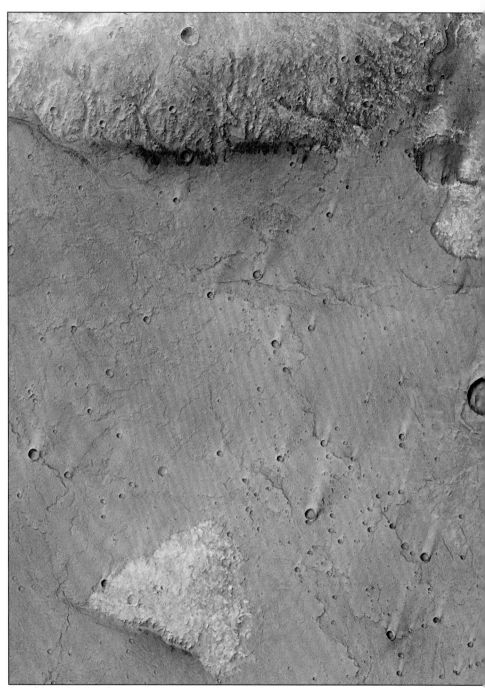

Part of the dark region of Mars called Syrtis Major, discovered by Huygens in 1659 and visible with a modest amateur telescope on Earth.

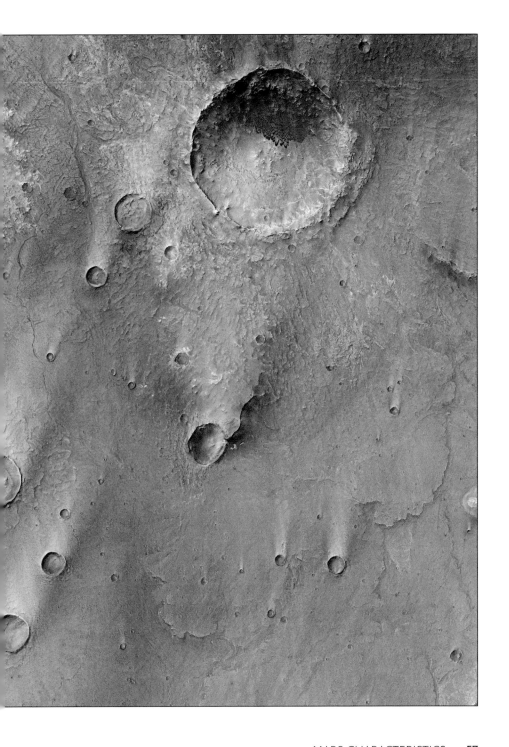

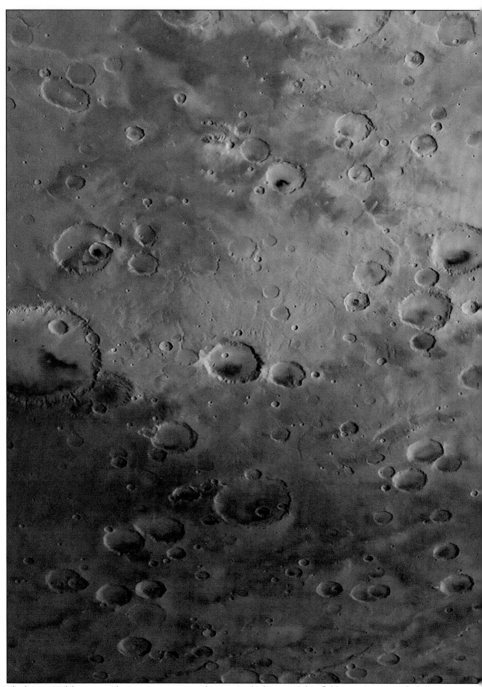

The huge 450-kilometre-wide Huygens crater can be seen in the bottom right of this ESA image, with dark volcanic dust deposits that accentuate the inner ring within the crater.

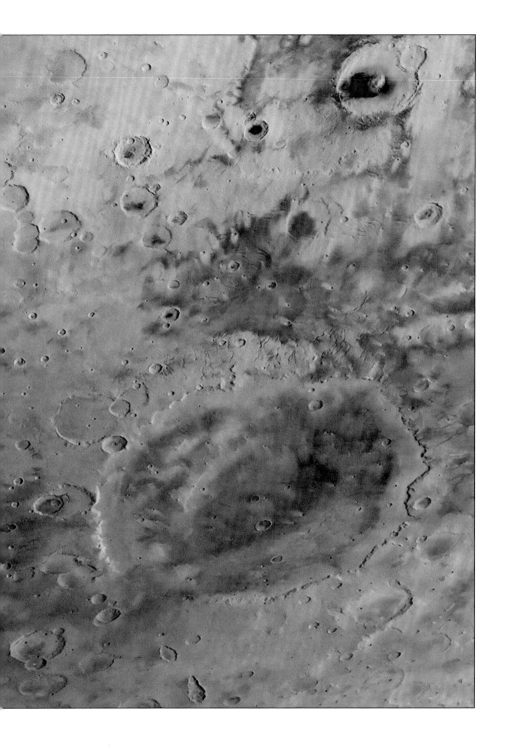

different geological and tectonic processes compared with other regions on Mars. Jezero Crater just northeast of Syrtis Major was chosen as the landing site for NASA's *Perseverance* rover, due to the diversity of geology that borders this region and the Isidis Planitia (a lowland plain).

HUYGENS CRATER

Situated a little north of the Hellas Basin, Huygens Crater may not be the largest but is distinguished as a large, well-defined crater and is a rare record of the effect of major impacts on the Martian landscape. Looking at the global map of Mars, it's easy to see the inner ring within the crater. This is not a lucky second strike from a smaller asteroid in the same location: a single impact had such tremendous force that the ground on Mars rippled and rebounded to create an inner ring within the crater. While

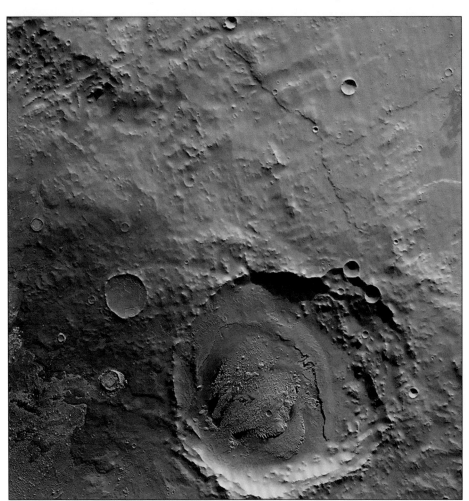

The large crater in the lower portion of this image is named after Giovanni Schiaparelli famous for naming 'canali' features on Mars. While no canals exist on Mars, the crater floor here has many features indicative of a past watery environment.

this was not an uncommon event on Mars, many other craters have had their inner rings eroded by wind or additional impacts leaving us few pristine examples to observe today.

The crater measures 450 kilometres in diameter. Using the crater counting method of dating, it is estimated to be almost four billion years old and therefore one of the most ancient features on Mars. The rim of Huygens features erosion in a tree branch pattern, most commonly associated with river tributaries. Chemical evidence of past flowing water here was provided by the detection of carbonates via NASA's *Mars Reconnaissance Orbiter*. Carbonates form when carbon dioxide in the form of gas dissolves in liquid water.

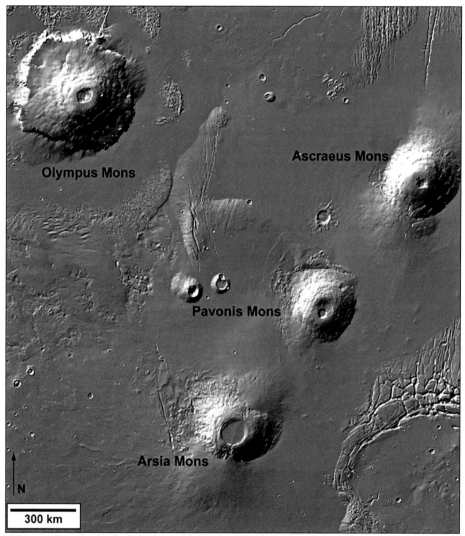

This image shows the trio of extinct volcanoes that make up the Tharsis Montes: Arsia, Pavonis and Ascraeus Mons.

SCHIAPARELLI CRATER

Similar in size to Huygens Crater at 460 kilometres across, Schiaparelli Crater is located west-northwest of Huygens, just below the Martian equator. It is named after the first true cartographer of Mars and accidental instigator of the debates about life on the planet in the 19th century.

Schiaparelli is relatively shallow compared to other similarly sized craters and features evidence of a previous watery environment. Mars orbiters have detected dark sediments on the crater floor that resemble lakebeds on Earth. The crater has featured in science fiction, most prominently in the book and film *The Martian*. In that fictional story, astronaut Mark Watney must travel 1,000 kilometres to reach the crater, using the natural terrain at its rim to find the gentlest way down to the spacecraft for his escape.

THARSIS MONTES

This feature comprises three extinct shield volcanoes that together make up the Tharsis Mountains (or *Montes* in Latin). From southwest to northeast, they are: Arsia Mons, Pavonis Mons and Ascraeus Mons. It is suspected that they formed one after the other via a *mantle plume*, which fed extra-hot magma from the core, through the mantle and up to the planet's surface, but moved while doing so to generate the three separate eruptions.

The Tharsis region in which these volcanoes are located in is a large area comprising a gently sloping bulge. The three peaks are situated towards the middle, where the bulge is at its highest. This means that even though Olympus Mons wins the height contest, the Tharsis Montes peaks are only a few kilometres shorter, as the bulge has elevated their baseline. The width of Olympus Mons's caldera is only 80 kilometres, compared to that of Arsia Mons, which features a caldera 110 kilometres wide. The difference is noticeable even at the scale of the Mars global map.

AIRY CRATER

Despite being a very modest crater on Mars with a diameter of only 43 kilometres, Airy Crater holds special significance due to its location. The clue is in the name, as George Biddell Airy was Astronomer Royal at the Royal Observatory, Greenwich, in the 19th century, and responsible for establishing the 1851 Greenwich Meridian that was adopted by most countries as the Prime Meridian of the world in 1884. This position of zero degrees *longitude* defined the 'middle line' of Earth on maps the world over. Just as Earth needed a Prime Meridian for consistent mapping, so did Mars.

This crater on Mars was actually chosen as the Martian meridian decades before Airy's work on the Greenwich Meridian, and was simply marked 'a'. However, in 1973 it was renamed in his honour. High-resolution images from NASA's *Mariner 9* spacecraft in 1971 revealed an even smaller crater inside it which astronomers named Airy-0. It is the centre point of this feature that is used to define the modern and accurate Mars Prime Meridian today.

MEDUSAE FOSSAE

This 1,000-kilometre-long stretch of trenches (*fossae* in Latin) lies at the boundary between the relatively smooth and low-lying plains of the northern hemisphere and the relatively cratered highlands of the southern hemisphere. The feature originated from a combination of volcanic activity and wind erosion. It's thought that during the Hesperian period, volcanic eruptions from the Tharsis region coated a large area of the surrounding terrain in thick layers of volcanic ash and hot gases that compacted and solidified to form very light and porous rock, similar to *pumice*. This rock was and still is not very

Digital terrain model of Medusae Fossae using ESA Mars Express imagery. This region is thought to be the majority source of dust on Mars due to wind erosion.

dense and is susceptible to wind erosion. Various smaller trenches act as wind tunnels, further increasing their depth over time.

The dust that is sheared off the Medusae Fossae is carried far. In fact, the iconic seasonal dust storms on Mars are thought to be fed by this one gigantic formation. Studies have produced chemical matches between the Medusae Fossae and various Martian rover dust samples collected from different regions of Mars. This makes it the largest source of dust on Mars, with three million tonnes being deposited across the Martian globe per year. This is enough to explain the deep layer of dust, ten metres thick on average, which covers the planet's surface.

Moons of Mars

Phobos and Deimos are such small moons that they are not massive enough for gravity to pull them into a round shape like Earth's Moon. Instead, they are misshapen lumps of rock, metal and ice, resembling potatoes or large asteroids.

They were discovered within six days of each other in 1877, by American astronomer Asaph Hall, and have been regularly observed since. Astronomers have very detailed knowledge of the orbits of the two moons and their ultimate fates in the distant future.

The origin story for Phobos and Deimos is still being debated. One proposed explanation is that they were passing asteroids captured by the gravity of Mars. Recent data from the European Space Agency's (ESA) *Mars Express* spacecraft, however, contradicts this. The information gathered points to both moons containing primitive material from the early Solar System and being of porous composition. Both this and their near-circular orbits suggest that the moons formed around Mars rather than being objects captured as they flew by. They may have coalesced from leftover material from Mars's formation 4.6 billion years ago. Or they may have been an accumulation of debris from multiple large asteroids that struck the planet's surface in the distant past, parts of which were then catapulted back into space above

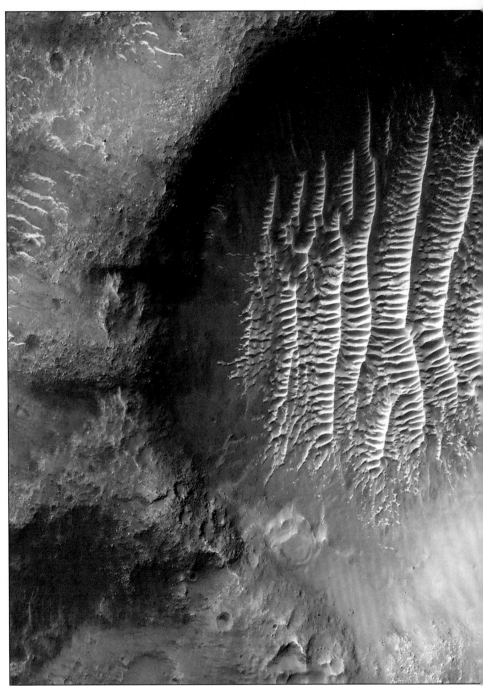

Image of Airy-0, a crater that sits within the larger Airy crater, historically referenced as the marker for zero degrees longitude on Mars. The floor of the crater displays the mesmerising pattern of Martian dunes.

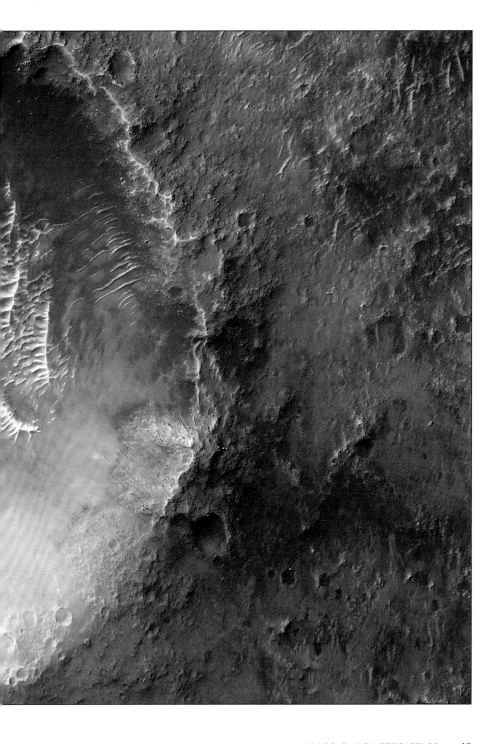

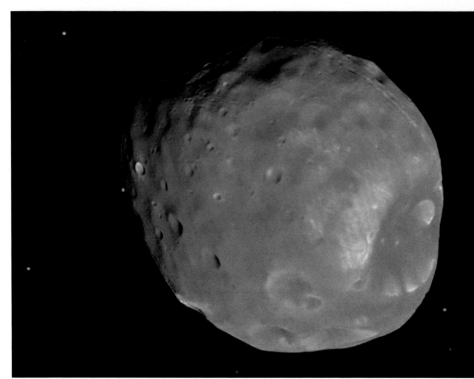

A composite image of the two moons of Mars, Phobos on the left and Deimos on the right. Size to scale, but distance is not to scale.

Mars. While the asteroid capture hypothesis cannot be entirely ruled out just yet, the evidence against it is growing.

Phobos and Deimos have been photographed from the surface of Mars by cameras on robotic rovers. Both moons also spin on their axes and create an interesting sight in the Martian sky, given their lumpy surface and varying regions of reflectivity.

PHOBOS

Phobos is closest to Mars at a distance of 6,000 kilometres from the planet's surface, and measures 26 kilometres on its longest side. Due to its proximity to the planet, it only takes a little over seven and a half hours to complete one orbit. As Mars takes over 24 hours to spin on its axis, Phobos orbits the planet three times over the course of

one sol. If someone were to stand on Mars and look up, they would see Phobos rise in the west and set in the east, the opposite to when we observe our Moon from Earth.

Phobos is slowly spiralling towards Mars at a little under two metres every century. In approximately 50 million years, this moon will suffer one of two fates. If its composition is solid enough all the way through, it will smash into and radically change Mars's surface. If it is less dense and has a loose rocky composition, the gravitational force of Mars will rip Phobos into small pieces forming a debris ring around the Red Planet.

The surface of this moon is heavily cratered all over, but dominated by one massive crater that looks like an enormous dent in its surface. This crater was named Stickney

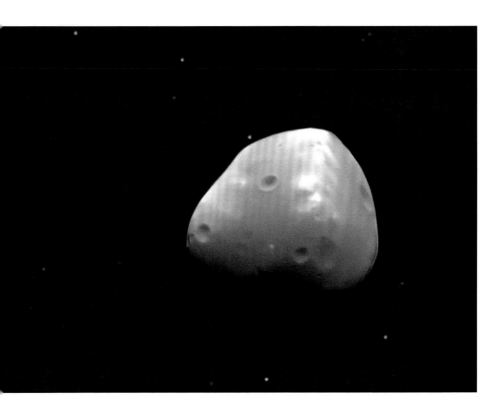

Crater after Asaph Hall's wife, Angeline Stickney, and is almost 10 kilometres wide, taking up a substantial area of the surface of Phobos. Many deep grooves can be seen in images captured of the region. At first glance they appear connected to the crater. Other massive impacts on bodies in the Solar System, like the Moon, resulted in material from the surface being kicked up and sprayed over the surrounding area, in a radial fashion, around the site of impact. However, in this case, the grooves carved run parallel to the crater rather than forming a radial pattern. There are also criss-crossing grooves that seem inconsistent with one giant impact.

That said, recent research shows that Phobos's low-gravity environment could have given rolling boulders, ejected from the impact, some unusual trajectories. The gravitational pull is so weak on Phobos that the boulders could have circumnavigated the lumpy moon, skimming the surface and changing course so that by the time they made it back to their rough starting position, they overlapped at an angle with the old grooves they made on their first trip around. This could explain the criss-cross pattern.

If one were to stand on Mars at the equator and look up at the right time, Phobos would be about one thirtieth the brightness of our Moon as seen from Earth. It would appear significantly smaller in the sky the further north or south of the equator you go. From the polar regions, Phobos wouldn't even appear above the horizon.

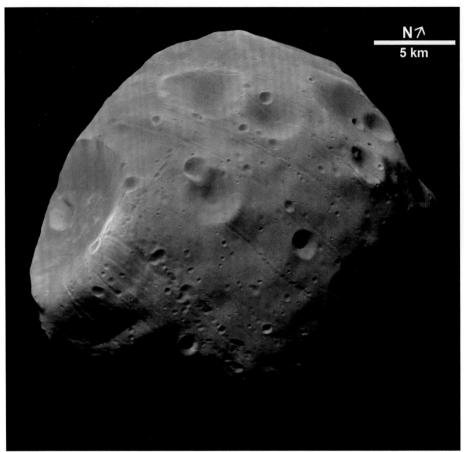

Image of Phobos showing the 'grooves' that were possibly carved by skimming boulders from the enormous impact that severely dented the moon.

Diameter: 26 km (along major axis)
Mass: 10.6×10^{15} kilograms
Density: 1,900 kilograms per metre cubed
Gravity: 0.006 metres per second squared
Average distance to Mars (centre):
9,378 km
Orbital period: 7 hrs 39 mins

DEIMOS

At an average distance of 20,000 kilometres from the surface of Mars, Deimos is the most distant of the moons and measures just 16 kilometres wide on its longest side. At that distance it takes Deimos a little over 1 sol (Mars day) to orbit Mars once. This moon does not exhibit the same unusual west-to-east movement in the Martian sky as its sibling, but it would still appear unusual to an Earthling standing on the surface of Mars. Since the time it takes to orbit is only six or so hours longer than it takes Mars to rotate once, Deimos would seem to crawl from east to west in the sky. Altogether it would take nearly three days for the moon to cross the sky and then another three days to reappear above the horizon.

In contrast to Phobos, Deimos is gradually

moving further from Mars. Although there are no firm estimates for when this will occur, in millions of years it will be lost beyond the gravitational reach of Mars forever.

Similar to Phobos, Deimos has a low density and porous structure. However, it is only approximately a fifth of the mass of Phobos, meaning its gravity is even weaker. Like its sibling, Deimos has suffered many impacts over billions of years, but much of the ejected debris escaped the surface of Deimos completely. Mars, however, clung onto this expelled material in such a way that the moon now spins and orbits through it, coating its surface in a generous layer of loose rock and dust.

Since Deimos is the most distant of the two moons, it appears from the surface somewhat fainter and one fifth the size of its sibling. Despite this, NASA's *Curiosity* rover has captured footage of the moon, including a silhouette imaged when it passed in front of the Sun on 17 March, 2019.

Diameter: 16 km (along major axis)
Mass: 1.5×10^{15} kilograms
Density: 1,750 kilograms per metre cubed
Gravity: 0.003 metres per second squared
Average distance to Mars (centre): 23,459 km
Orbital period: 30 hrs 18 mins

Snapshot of Deimos passing between Mars and the Sun, captured by NASA's Curiosity rover from the surface of the Red Planet.

3: HOW TO OBSERVE MARS

So far, we've covered a lot of the history and the theory of Mars exploration, but if you want to get out there and take a look at the Red Planet for yourself, this chapter is for you. You'll learn to understand what you're seeing by eye or through a telescope. There are other resources and software that describe the exact location of Mars on any given night, as seen from anywhere on Earth, so only a general guide and advice will be given here for its location in the sky. In terms of equipment, we'll cover a range of telescope types – some are reasonable value with a fairly good quality of view, while others can provide a surprisingly detailed view of Mars when combined with photography, but they come with a hefty price tag. This section of the book offers something for everyone, whether you're starting out or wanting to upgrade what you already have.

Finding Mars

Before going outside, preparation is key. Firstly, your location makes all the difference when it comes to viewing Mars. While Mars fluctuates in brightness depending on where it is relative to Earth and the Sun, it is always a fairly bright object when it is in our night sky. The best locations from which to view the planet are dark and away from streetlights or the glow of lights from a nearby town or city. After giving yourself at least 20 minutes to let your eyes adapt to the dark you will be able to pick out fainter stars in the sky, as well as the brighter stars and planets. Although an urban location is far from ideal, it is still possible to make out Mars at most brightnesses from areas of a town or city that are not directly lit from above, for example, by streetlights or billboards. Perhaps a more pressing consideration for seeing Mars is your line of sight. In urban areas, buildings can easily block whole parts of the sky near the horizon, leaving you with only a small circle of clear sky directly above to look at. The same can be said for the countryside, where trees and hillsides can obscure a great deal of the night sky.

As well as the impact of light pollution, the time of year and your *latitude* affect how dark the sky can get at night. Take, for example, Greenwich, which sits at a latitude of 51.5° north of the Equator. On the summer solstice (in June) at this location, the Sun only goes 14° below the horizon overnight. This means that the sky doesn't reach full darkness, with the Sun leaving a faint glow that acts as a form of natural light pollution. This reduces our ability to see fainter objects in the night sky with the naked eye. In contrast, on the winter solstice (in December), the Sun dips to over 60° below the horizon overnight in Greenwich, leaving no glow for Mars observers to contend with. Put simply, ideal viewing conditions are a dark sky during your location's winter months, with unobscured views all around down as far as the horizon and, of course, a cloudless night.

In reality, observational astronomy involves compromises and trade-offs. There is plenty of room for flexibility as you can plan Mars observations to coincide with when the planet rises above any obstructions in your locality. In fact, it will be at its clearest when it is highest in the sky. This is where light travels the shortest distance through our atmosphere. Weather will often be the overriding factor – a compromise often has to be made between the best sky conditions and the position of your target.

No matter the time of year, Mars will be located along a band in the sky astronomers refer to as the ecliptic. All the planets in the Solar System orbit the Sun in a roughly flat plane with little variation. There are

13 constellations that are seen along the path of the ecliptic in the sky. They are:

- Aquarius (Aqr)
- Capricorn (Cap)
- Sagittarius (Sgr)
- Ophiuchus (Oph)
- Scorpio (Sco)
- Libra (Lib)
- Virgo (Vir)
- Leo (Leo)
- Cancer (Cnc)
- Gemini (Gem)
- Taurus (Tau)
- Aries (Ari)
- Pisces (Psc)

The number of visible constellations at any one time varies with location and the time of year. You will probably notice that 12 of them are commonly known as the signs of the zodiac in astrology. Without more detailed information you could simply look for Mars by familiarising yourself with the shapes of these constellations and looking along that band of star patterns in the sky for a red point of light. It won't twinkle, and it should appear steady in comparison to any nearby bright stars. If it is not visible, Mars is most likely below the horizon.

However, to eliminate the need for guesswork, there are a number of tools that can be used to locate Mars. If you prefer not to rely on applications on a smartphone or computer, the table in this chapter shows which constellation Mars is situated in on the first of every month from late 2024 to 2035. A faster way is to use an application such as *Stellarium*, which is open source and freely available for any computer or smartphone, or as a web application at stellarium-web.org. This application can automatically detect your current location, or you can specify where you are in the location settings. You can search for Mars and use the time controls to fast-forward to when Mars is in a favourable position in the sky.

Mars is sometimes positioned too close to the Sun in the sky, making it difficult or dangerous to view, since it will be lost in the glare of the Sun. You should never use binoculars or a telescope to look for objects near the Sun in the sky, as it risks temporary or permanent damage to your eyesight.

Diagram of the ecliptic, which represents the plane of the Solar System along which the planets orbit the Sun. From Earth, this imaginary marking lines up with the star patterns sometimes known as the Zodiacal constellations.

It may mean having to wait it out for weeks or months until there is enough separation between the Sun and Mars to safely and easily see it before sunrise or after sunset.

When outside in the dark, try to avoid using your phone as a light to find your way around in the dark or to double-check things on your screen – this will have a negative impact on your night vision. Instead get yourself a red-light torch. Red is the lowest-energy light colour our eyes can see, and so it is the least destructive to our night vision. Many head torches have a red-light mode with the added benefit that your hands are free, which is helpful if operating a telescope. If you have to use your screen (for instance, to check an astronomy app) try to use a red-light mode in the app, from your display settings or through a dedicated red-light-mode app.

Now you can begin to orient yourself to the night sky. A great first step if you are

in the northern hemisphere is to find the Plough in the sky. This looks like a large, long-handled saucepan made up of seven bright stars. From the rim of the saucepan furthest from the end of the handle, draw an imaginary line between the two stars there. This line points towards a star of similar brightness called Polaris, our current north star. It is situated 30° from the nearest pointer star. This measurement can be demonstrated by extending your arm fully, making a vertical fist and then visualising three of them one on top of the other. The Plough is not a constellation itself, but rather an easy-to-recognise pattern in the sky called an asterism. It is part of the constellation of Ursa Major, the Great Bear.

Depending on the constellation in which Mars is located, you may need to find your way along the signs of the zodiac by referring to some of the asterisms within those constellations. We can go through

Star chart that shows how to use the Plough star pattern to find the North Star (Polaris). The orientation of the Plough relative to the North Star varies depending on the time of night and time of year.

LOCATION OF MARS BY CONSTELLATION*

01 November 2024	Cnc	01 August 2028	Gem	01 April 2032	Ari
01 February 2025	Gem	01 October 2028	Cnc	01 May 2032	Tau
01 May 2025	Cnc	01 November 2028	Leo	01 July 2032	Gem
01 June 2025	Leo	01 January 2029	Vir	01 August 2032	Cnc
01 August 2025	Vir	01 September 2029	Lib	01 September 2032	Leo
01 November 2025	Lib	01 October 2029	Sco	01 November 2032	Vir
01 December 2025	Oph	01 November 2029	Sgr	01 January 2033	Lib
01 January 2026	Sgr	01 January 2030	Cap	01 March 2033	Oph
01 February 2026	Cap	01 February 2030	Aqr	01 April 2033	Sgr
01 March 2026	Aqr	01 March 2030	Psc	01 November 2033	Cap
01 May 2026	Psc	01 May 2030	Ari	01 December 2033	Aqr
01 June 2026	Ari	01 June 2030	Tau	01 February 2034	Psc
01 July 2026	Tau	01 August 2030	Gem	01 March 2034	Ari
01 September 2026	Gem	01 September 2030	Cnc	01 May 2034	Tau
01 October 2026	Cnc	01 October 2030	Leo	01 June 2034	Gem
01 November 2026	Leo	01 December 2030	Vir	01 August 2034	Cnc
01 August 2027	Vir	01 March 2031	Lib	01 September 2034	Leo
01 October 2027	Lib	01 June 2031	Vir	01 November 2034	Vir
01 November 2027	Oph	01 August 2031	Lib	01 January 2035	Lib
01 December 2027	Sgr	01 September 2031	Sco	01 February 2035	Oph
01 February 2028	Cap	01 October 2031	Oph	01 March 2035	Sgr

*Please note entries do not discriminate between daytime and nighttime constellations. For missing months, this means Mars has not entered another constellation by the 1st of that month, so refer to the constellation of the previous month.

Location set at +51.5° latitude, 0° longitude.

some highlights here that will help with finding Mars.

- Sagittarius contains the Teapot, which looks exactly like that, complete with a handle and spout.
- Leo contains the Sickle asterism, which has the appearance of a backward question mark.
- While not containing an asterism, Gemini is another standout constellation as it contains the bright stars Castor and Pollux right beside each other. These represent the heads of the twins of the same names.
- Taurus contains the Bull's Head, which resembles two long horns protruding from a bright red star called Aldebaran (not to be confused with Mars).

Even if Mars isn't located in one of these easy-to-recognise constellations, these tips will help you trace out the curved line of the ecliptic which you can search along for the Red Planet.

You can also attempt to match what you see in the sky with the star maps provided by astronomy apps. Some even come with an AR (Augmented Reality) mode so you can hold your phone at arm's length against the sky and again match the digital representation of Mars with its real-life counterpart. If you wish to avoid the glare of a phone screen, you could purchase a planisphere, a large cardboard or plastic dial that helps you locate particular stars in the night sky. Simply rotate the dial to set the sky to the month and it can show you the location of the stars in and around a particular latitude (plus or minus 10°).

While you won't be able to see any actual detail when only viewing Mars by eye, you can experience some of the observations of the earliest astronomers by noting down the planet's changing magnitude over the months, and special events such as the occultation of Mars by the Moon, when the planet is covered by the Moon in the sky. Mars can sometimes be seen near other planets in an event called a conjunction, which can be captured on camera (whether that's a smartphone or a digital camera). As these are infrequent special events, they are particularly prized by amateur and professional astronomers and astrophotographers alike.

To get to the next level of observation, a telescope is required and potentially a suite of accessories if you intend to capture a photograph of Mars.

Equipment Recommendations

There are no strict rules on where to begin along the range of observing equipment from budget beginner to expensive expert. However, it is a good idea to start small and basic in order to learn how to move around the sky, before getting sidetracked by elaborate motorised telescopes and digital photography add-ons. A good entry point beyond observing by eye is a medium-sized pair of binoculars. In the case of Mars, they won't show any surface detail, but they can give a view of the planet as a small orange-brown dot rather than a pinprick of light barely distinguishable from the stars. Just again, a warning – never use binoculars, telescopes or even your naked eye to look directly at the Sun as this causes irreparable eyesight damage.

Binoculars are always marked with two figures in the format <number>x<number>, for example 10x50. The first number refers to how many times magnified the image is compared to your unaided vision. The second number refers to the diameter of each lens in millimetres. The larger the first number, the stronger the magnification. The larger the second number, the more light is gathered, thus increasing the visibility of fainter objects. 10x50 binoculars occupy a sweet spot for beginners and experienced

observers alike. Ten times magnification is sufficient to make out planets as discs and to identify the rings of Saturn and the largest moons of Jupiter. While it is tempting to purchase binoculars with higher values for a better view, they also come with a higher price tag and can be harder to use. With larger lenses, binoculars become heavy and very difficult to hold. This is important with high magnifications, binoculars must be held absolutely still as even the slightest tremble will distort your view a lot and may cause you to deviate completely from your target. There is a point that is reached, say, for 25x100 binoculars, where they become truly unwieldy, and their portability advantage is lost. Given the price, a similarly sized, or bigger, telescope will be a better investment.

Binoculars are excellent for swiftly scanning the sky with enhanced vision to better get to grips with moving from constellation to constellation. For the recommended 10x50 binoculars, there are a couple of accessories worth getting to steady your view of Mars, enabling you to see the disc clearly in sharp focus. The first is an L-bracket for binoculars and the second a photography tripod. The L-bracket is screwed to the front of the binoculars and the combination is attached to the screw top of the tripod. From this secure position you are set for steady (if small) views of Mars, but you can easily detach the binoculars again to look around the sky more freely. A final point worth mentioning is that when the time comes to upgrade to a telescope, your binoculars are not wasted. They are an excellent portable companion for orientation and if you decide to try your hand at photography with a telescope, you can use binoculars to look at other interesting features in the night sky while you wait for images or videos to be captured.

Choosing a telescope for observing Mars can be a daunting task given the variety of configurations. The two main types of telescope are refractor and reflector. A refractor gathers light with a combination of lenses to magnify objects, with the primary light collector being a lens at the front of the tube. A reflector typically gathers light with a combination of mirrors and lenses – the primary light collector is a mirror inside the base of the telescope tube.

In both instances, the gathered light is magnified and brought into your eye via an eyepiece. This stocky tube contains a series of lenses, sometimes quite complex, that expand the image and focus it onto your eye. The observer can control the magnification of the telescope by swapping eyepieces. The eyepiece can also be removed entirely to allow a digital camera to be inserted. To determine the magnifying power of a telescope, its focal length is divided by the focal length of the eyepiece. Without going into too much detail, focal length is the distance that light travels from entering one piece of optics to reaching another (for example, from where light enters an eyepiece to where it comes to focus for your eye).

A variety of different refractors and reflectors are available on the market. The first type of telescope to mention is the one known to many – a Galilean refracting telescope. It is made up of a long narrow tube holding a large lens at one end and a smaller one at the observer end.

A simple and common type of reflecting telescope is a Newtonian reflector. This is made up of a wide tube sealed at one end and open at the other. Inside the sealed end is a face-up mirror, while a much smaller secondary mirror is suspended via thin metal struts near the open end at the top. The latter is at a 45° angle to the side of the telescope tube and the primary mirror. Light enters the tube, reflects off the primary mirror at the bottom and is then reflected by the secondary mirror towards the eyepiece or camera. Both telescope types come in

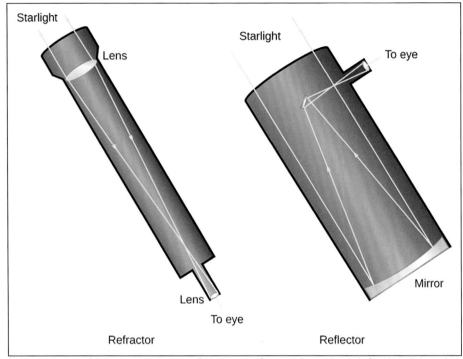

Starlight

Lens

To eye

Starlight

Lens

To eye

Mirror

Refractor

Reflector

Light ray diagram of the two main categories of telescope. A refracting telescope bends (refracts) the light to the viewer using lenses, while a reflecting telescope primarily reflects the light to the viewer using mirrors.

a variety of sizes and are classified either by the primary lens or the primary mirror diameter – for example, an 80 mm refractor or a 130 mm reflector.

A small Galilean refractor or Newtonian reflector can be a good beginner telescope, but the typically larger reflectors have a few advantages for viewing planets. A mirror, unlike a lens, can be mounted on the end of the tube, as light only reflects off it and doesn't need to pass through it. It is also thin and light compared to a thick lens. You can purchase a much larger reflector for significantly less than a large-lensed refractor. The diameter of the primary lens or mirror dictates the amount of light collected by the telescope. This in turn affects which eyepiece will offer the maximum useful magnifying power.

A good value variation on the basic Newtonian reflector is a Dobsonian telescope. It's named after its inventor, John Dobson, who came up with the idea in the 1970s. Sitting on a rocker that has a turntable as its base, the telescope is incredibly easy to move around, without compromising on stability. This design allows the base to hold and handle a truly enormous telescope tube with ease. However, the drawback is that this makes for a very large piece of kit which isn't very portable, and can be difficult to store if space is at a premium. Some designs include an open truss configuration that means the telescope can be folded down, which compensates somewhat for this.

There have been other innovations created since the Galilean and Newtonian designs, which have played with the configuration

Photograph of a Dobsonian-style telescope. All brands use the same floor-standing rocker-style base and typically include a simple Newtonian reflecting telescope.

Light ray diagram of a Schmidt-Cassegrain telescope. Following the dashed line illustrates how a combination of mirrors and smart design can elongate the total light path to create a compact but powerful telescope.

of mirrors and lenses to compress the size of telescopes and correct visual defects, resulting in higher production costs and, in turn, higher sale prices. The most notable of these on the consumer market are the Maksutov-Cassegrain telescope (MakCass for short) and Schmidt-Cassegrain telescope (SCT). Since the potential maximum magnification of a telescope is governed by both the focal length of the eyepiece and the telescope, shortening the former and lengthening the latter increases the magnifying power.

$$M = f_o/f_e$$

Where M is the magnification, f_o is the focal length for the objective (i.e. primary mirror or lens) and f_e is the focal length of the eyepiece.

While eyepieces become trickier to manufacture the shorter the focal length is, a telescope light path can be extended relatively easily. One method is to lengthen the tube, but another is to only lengthen the path light itself takes. This is done in some telescopes by reflecting the light several times within the tube. In the diagram above (right) you can see the light ray has a back-and-forth journey thanks to the ingenious positioning of the various mirrors with holes to let light through when needed.

In the case of MakCass telescopes and SCTs, those designs also introduce a front lens element called a corrector plate, which corrects for the curvature of the primary mirror, ensuring that the resulting image is not warped. Since they include large lens elements, the price for these models

rises fast with the lens diameter, but the results are stunning. The smallest variants, while hardly budget, are very impressive for value, portability and surprising-for-their-size maximum magnifications. A generic MakCass with a modest diameter of 102 mm can achieve a maximum usable magnification of 200 times – more than adequate to see surface detail on Mars.

Telescopes can be placed on top of two distinctly different mounts. The first is called an alt-azimuth mount, short for altitude (up or down in degrees) and azimuth (moving horizontally clockwise or anticlockwise in degrees). The second is known as an equatorial mount and moves in 'right ascension' and 'declination', which equates to left and right, and up and down, respectively. An equatorial mount traces a curve across the sky and must be in parallel to the rotational axis of the Earth to accurately track objects in the sky. This is achieved by aligning the mount to Polaris (the North Star). This allows the equatorial mount to track in one axis, while an alt-azimuth needs to move in two axes (i.e. vertically and horizontally). This makes an equatorial mount a smooth tracking system and the best fit for precision astrophotography.

Both of these mounts can be motorised in order to track objects in the sky and therefore keep them within the field of view for a reasonable period of time. The trade-off is that they then require power in the form of built-in batteries, a plug-in battery pack or a cable that runs to the mains. The motorised mounts also usually come in one of two modes – a PushTo or GoTo configuration. The former means that, even though it is motorised, you still need to press buttons to make the mount go left or right, and up or down. The GoTo type is usually linked to satellite navigation technology so that it can find a target once you have selected it on a keypad menu or app. With these mounts it is possible to locate and view Mars and its features surprisingly quickly and with minimal effort.

Observations and Accessories

If you don't yet have experience of observing with a telescope, you may have high expectations of what you will see, influenced by the extraordinary detail of images online and in magazines. The first thing to realise is that a person with a large and expensive telescope may have a poorer view than another person with a budget-friendly telescope on two different nights in the same location. This is where an atmospheric effect called 'seeing' comes into play. The seeing effect is the distortion of light through our atmosphere due to a variety of small changes in air density and air currents. This turbulence is ever-present in our atmosphere, but on some nights the fluctuations are minimal and on others the light from stars and planets shifts dramatically. In basic terms, the end result is an amount of 'wobble' in what you see by eye or through binoculars or a telescope. The wobble is more pronounced in highly magnified views. For Mars, this could mean the difference between being able to see some of the darker regions of Mars and the polar icecaps and observing a blurred orange-brown dancing blob. To check if the seeing is reasonably good on any given night, look at any bright star near the horizon. If it is dancing around a lot, you may want to wait until later that evening to start viewing or choose another clear night.

All telescopes – regardless of model or cost – should be set up outside in good time before they are used, so that the optics can cool down. Without this cooldown period, any warmth in the telescope heats the air around it and the resulting turbulence blurs your view. The larger the telescope, the longer the cooldown time required. A rough

estimate that can be used is five minutes per inch of telescope width (for example a 130 mm wide telescope would need 25 minutes for cooldown).

Diameter of Primary Lens/ Mirror	Cooldown Time
80 mm (3 in)	15 minutes
150 mm (6 in)	30 minutes
180 mm (7 in)	35 minutes
356 mm (14 in)	70 minutes

For viewing Mars by telescope, it is important to bear in mind the change in the size of Mars in the sky over time, depending on its position relative to Earth. Timing your viewing for when it is due to make a close approach is best. Mars next reaches a close approach of 70 million kilometres or less in 2033, 2035, 2050 and 2052, but this does not mean viewing it is pointless at other times. The weeks around the opposition of Mars, when Earth lies almost directly between the Sun and Mars and the planet appears at its brightest, offer very favourable planet-viewing opportunities.

Next Mars opposition dates	Earth-Mars distance
16 January 2025	96 million kilometres
19 February 2027	101 million kilometres
25 March 2029	97 million kilometres
27 June 2033	65 million kilometres

We can expect that June and July 2033 are going to provide a relatively bright and large view of Mars, but northern hemisphere observers will have to contend with limited hours of darkness to view it. You can check Mars visibility in your location by using the stellarium app and setting the location and time appropriately.

After following the set-up instructions for a particular telescope and its mount, the most important step is to align the telescope's finder to the view in your eyepiece. A finder is usually a very small telescope or red dot laser finder that is piggybacked onto the main telescope tube. This gives you a wide view of the sky and allows you to point the telescope in the correct direction.

To align the finder, make sure your mount is not tracking (if applicable) and choose a distant target on land such as a rooftop aerial, streetlight or other distinct feature. Place your lowest-power eyepiece into your telescope, i.e. the one with the biggest number in millimetres labelled on it. While looking through the finder, move the telescope so that the red dot or crosshair is centred on your chosen target on land. Then look through the main telescope and see where it is. Move the main telescope until the target is centred in the view. Go back to the finder and you should find some form of adjusting screws, which can be used to change the finder view, so that the object is back in the centre again. Choose another object on land or a bright star to check the alignment. If the finder view and telescope view don't match, you may need to make another adjustment with the finder screws.

Before viewing Mars, point the telescope at a bright star and adjust the focus using the knobs either side of the eyepiece. You will know the telescope is in focus when the star is as small as it can appear, like a pinprick of light. The view will probably wobble a lot as you turn the focus knobs but pausing adjustments for a few seconds should allow the view to settle down nicely.

Overleaf are some examples of which features on Mars can be seen in ideal sky conditions using a variety of telescopes,

from budget to top-of-the-line, with the same eyepiece accessories. Please note that the views shown are simulated without consideration of the atmosphere, seeing conditions or an individual's eyesight. All images were sourced from the Solar System Simulator created by NASA's Jet Propulsion Laboratory.

There is no single 'best choice' telescope, being more a matter of personal taste and available budget. It can be very beneficial to attend a local astronomical society's star party, where you can try a variety of telescopes to get a feel for them. In terms of cost, it's worth bearing in mind that a good telescope mount can be repurposed

Mars as seen with 80 mm Refractor (10 mm eyepiece 2x Barlow Lens)

Mars as seen with 180 mm MakCass (10 mm eyepiece 2x Barlow Lens)

Mars as seen with 150 mm Reflector (10 mm eyepiece 2x Barlow Lens)

Mars as seen with 14 inch (356 mm) SCT (10 mm eyepiece 2x Barlow Lens)

for some larger telescopes down the line, meaning a lower long-term overall spend.

There is a huge range of telescope accessories that can enhance your viewing experience and the following are likely to be particularly useful when it comes to Mars.

BARLOW LENS

While most telescopes come with one of these already included, you may wish to upgrade it. This accessory goes into the eyepiece-holder of any telescope and an eyepiece is then inserted into it. The Barlow lens has a number, usually 2x, which means it doubles the focal length of the telescope, effectively doubling the magnifying power. They also come in 3x and 5x varieties. Those varieties should not be used on smaller telescopes as they can't gather enough light to usefully magnify to this degree, resulting in a very blurry view.

EYEPIECES

Most telescopes come with at least two eyepieces, usually one that provides low magnifying power and one that provides higher magnification. Combined with a Barlow lens, this will give users four potential magnifying powers. While this is enough to get started, it could be worth investing in better-quality versions for a clearer, more colour-accurate view. You could also get a very short focal length eyepiece (4 mm, for example), to increase the maximum magnification. In addition, zoom eyepieces can change the focal length of the eyepiece with a built-in adjustment, making it unnecessary to swap different ones in and out, although they can be of inferior optical quality.

FILTERS

Filters for telescope eyepieces usually come in 1.25-inch-wide configurations. They screw into the end of an eyepiece tube and are available in a variety of colours. An orange or red filter will help enhance the contrast of surface details on Mars, which are otherwise typically low-contrast and difficult to spot.

RIGHT-ANGLED FINDER TELESCOPE

All telescopes will come with a finder to help guide the telescope manually to your chosen target. However, depending on the telescope, your own physical flexibility, and the altitude of the object you're looking at, it can be difficult or even painful to look along the main telescope tube through the finder. A right-angled finder telescope redirects the light to the side, and can be a lot more comfortable to look through as a result.

BATTERY PACK

For any telescope that requires power, a battery pack provides a longer-lasting and more sustainable approach to feeding it batteries. Lithium Polymer power packs are particularly good at holding their charge between observing sessions and usually come in a robust casing suitable for the outdoors. A battery of 8 Ah (Amp hours) capacity or more is suitable for most telescope power needs.

BUBBLE LEVEL

This may or may not come with the telescope you purchase. It is simply one part of a spirit level to show how level your telescope mount is wherever you are positioning it. If you can't get your hands on one, there are app equivalents that use your phone's sensors instead. Having a level telescope mount is particularly important for astrophotography.

DEW SHIELD

Over time and when using a telescope at night in very cold temperatures, dew will begin to fog up the optics of your instrument. While it can't prevent this from happening entirely, a dew shield acts like a hood to keep lenses and mirrors fog-free for longer.

HEATING STRIPS

Sometimes a dew shield alone is not up to

the task for extended sessions in very cold conditions. Heating strips do exactly as their name suggests. They can be tied around the telescope and plugged in to stop dew forming at all.

Photographing Mars

While viewing Mars through a telescope is rewarding in itself, photographing the Red Planet can provide new rewards – allowing an observer to identify more subtle surface details and make seasonal comparisons. Thanks to the smartphone in most people's pockets, the bar to entry for planetary photography with a telescope may be lower than you think.

Smartphone telescope adapters can be purchased online from a variety of manufacturers. Most clamp onto the telescope eyepiece and can be adjusted up and down as well as left and right to get the best alignment between the camera lens and the eyepiece. An orange or red filter for your eyepiece can be used to enhance the smartphone camera view. To achieve the best results, a camera app with manual controls for *exposure* should be used. While it's tempting to digitally zoom in on Mars, try to avoid anything except optical zoom to retain as much detail as possible – you can always crop the resulting image later. Through a combination of tapping Mars on the screen to focus on it and experimenting with the exposure slider, it should be possible to achieve a crisp view of what you would see through the eyepiece alone. If your camera app has a 'burst mode' or equivalent, you can capture a series of photographs and choose the clearest from the set. Use the timer setting too so that the telescope has a few seconds to settle after being wobbled by touching your smartphone. Alternatively, you can record a short video to be processed on a computer later using the same techniques you would employ for a dedicated digital camera.

Although this is an excellent low-cost starting point for photographing Mars, the combination of the eyepiece lenses and those in your smartphone camera will create many distortions in the final image. The sensor in the phone camera will also be small and prone to *digital noise*. The next step up from this is either a digital camera with a removable lens or a dedicated astronomy camera, referred to as an astronomical *CCD*.

While the astronomical CCD will provide superior light sensitivity and speed (frames captured per second), a digital camera is a good-value purchase because of its flexible use beyond astrophotography. We'll cover the steps involved in attaching such cameras to a telescope, and conclude this section with additional notes relevant to using a dedicated astronomical CCD.

A modern digital camera could be a *DSLR* or mirrorless model. In both cases, it is possible to remove their lenses, giving direct access to their CCD – the light-detecting chip that captures incoming photons of light. In order to attach these cameras to a telescope one or two accessories are required. The first is called a T-ring, which will be camera-manufacturer-specific and can be locked into place where the lens once sat. The second is called a T-adapter, which screws into the T-ring. Helpfully, some Barlow lenses already feature a built-in T-adapter and may be necessary anyway to achieve focus with your particular set-up. A T-ring and T-adapter-equipped camera can be slotted and fixed into the eyepiece holder of a telescope and held in place with the thumbscrew.

It should be noted that not every telescope is capable of supporting such kit, especially if you are using a heavy-bodied DSLR camera. You may need to adjust how your telescope is balanced on its mount or upgrade the mount to a sturdier one. If you are unsure or have not yet purchased your kit, it's best

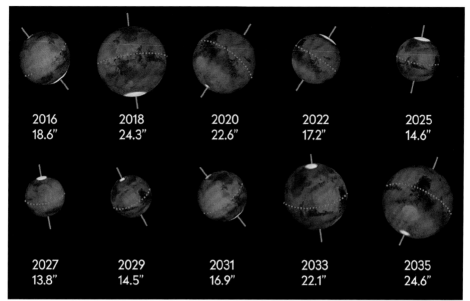

| 2016 | 2018 | 2020 | 2022 | 2025 |
| 18.6" | 24.3" | 22.6" | 17.2" | 14.6" |

| 2027 | 2029 | 2031 | 2033 | 2035 |
| 13.8" | 14.5" | 16.9" | 22.1" | 24.6" |

A comparison of Mars's apparent diameter when at opposition from 2016–35.

to consult with a telescope retailer or visit an astronomy photography forum to seek advice.

All the same logic will apply as before for setting up your telescope and finding Mars in the sky. However, now comes the additional challenge of finding Mars using the screen on the back of the digital camera. Before inserting the camera, ensure that you are happy with your normal telescope view of Mars and that any telescope troubleshooting is complete. This includes looking out for any dirt that may have accumulated on the telescope optics and, for a motorised mount, checking that the planet isn't drifting quickly out of view. Only then should the camera be inserted.

Start with a relatively long exposure like 1/125th of a second at ISO sensitivity 400 so that Mars appears bright on screen. As the chip in the camera is the replacement for your eye, the telescope will need to be refocused for a crisp view. Try to concentrate on getting the edges of the planet as clean and crisp as possible. Depending on the telescope, your initial view of Mars may be very large and blurred, but shrinks to a small dot when properly focused. Now you can begin shortening the exposure to see if any surface detail is visible, including the polar icecaps, dark regions and even dust storms (if the telescope is large enough). To ensure you're getting all the light data possible, ensure that the histogram function of your camera is switched on. This is a graphical representation of exposure. Try to ensure that the light curve displayed is not cut off anywhere. Provided there is no clipping along the graph, having a curve that is slightly shifted to the right will give you plenty of flexibility for post-processing.

To compensate for the seeing effects of the atmosphere, it is best to take video clips from which the clearest images can be selected using computer software. If you don't have a motorised telescope, you can still use software to create a centred and fixed video later, even if the planet is drifting out of view. In both cases, record a maximum of five

Screenshot of main page for PIPP software.

minutes of video footage. While keeping an eye on the histogram, experiment with ISO and exposure time and record more five-minute clips. It is better to have too much to choose from rather than too little.

The nice thing is that all of the next steps can take place in the warm indoors in front of a computer. Some free software that can be used for post-processing images are as follows:

1. *PIPP* This crops out empty space, roughly centres Mars in each frame and converts the video into a usable format for the next piece of software.
2. *AutoStakkert!* This will centre-align Mars precisely in all frames of the video, eliminating its wobble, and will stack the best frames into a single quality image.
3. *RegiStax* This will allow fine-tuning of colour, contrast and detail from the output of the previous step.

While free, the downside is that all the above are Windows-only pieces of software. There are some Mac and Linux equivalents online, but what follows will focus on the software above.

PIPP

Import the video from your digital camera into *PIPP*. Once you've opened your video file and it appears as a line of data in the window, click the 'Planetary' tick box at the bottom of the screen under 'Optimise Options For'. You can leave most settings to default but ensure that the cropping function is cropping Mars to your taste. This software has some functions that overlap with *AutoStakkert!*, but you can leave these, at least the first time round. Make sure that AVI is selected as the Output Format under the 'Output Options' tab and that AVI File Options are set to 'Uncompressed'. Finally, under the 'Do Processing' tab, click 'Start Processing'. Depending on the resolution and length of your video, this should only take a minute or two. Now you can move to the next step and next program.

AUTOSTAKKERT!

PIPP will have made a folder in the same directory as your original video file. In this you'll find an .AVI file to import into *AutoStakkert!*. Again, most settings can remain on default. You should see that there are steps labelled 1 to 3 in the window to the left of the window that is showing your

Screenshot of the main interface of AutoStakkert! software. Each step in the alignment and stacking process is labelled 1 to 3.

Secondary window in AutoStakkert! that displays an image preview and allows an alignment points (AP) grid to be placed and adjusted over Mars.

video of Mars. First, click step 1) Open, to open the .AVI file. Next click 2) Analyse. This will sort the frames from highest-quality sharp frames to poorest-quality blurred frames. The green curve on the graph that is generated shows how the quality declines. There will be a balance to taking only the choicest and sufficient frames to make the next step effective. You can choose to click anywhere on the green curve to select a cut-off, for example the top 25%, the top 50% and so on. You can choose to do multiple runs in one go and process up to four different cut-off percentages to experiment with. Perhaps keep it simple on your first attempt and select or enter top 25%. The step 3) Stack button will be greyed out until you select the 'Place AP Grid' button on the other window that shows your video preview. AP stands for 'alignment points' and once it's clicked you should see a lot of boxes of the same size overlaid on Mars. Before proceeding, try increasing the 'Min Bright' option above the button you just pressed. This should ensure that only clearly visible contrast points are used for the alignment process. Now click the 'Place AP Grid button' again. Finally click the step 3) Stack button in the other window and, after a few minutes of the process of aligning and stacking, each frame should complete. The stacking process helps to bring out the signal in the images combined and reduce the noise overall. By doing this, the image should be able to withstand more post-processing than a single noisy frame that will probably look very messy on its own.

REGISTAX

The previous step will have produced an image file with AS in the name in a new folder within the *PIPP* folder. In previewing the image, it might not look as if there is much improvement over a single frame of the original video. However, there is a lot of hidden detail that *RegiStax* can extract from that image, if used correctly. Once you open the stacked image in the program, look for and click 'View Zoomed' in the grid of grey buttons on the right of the window. This will help you closely monitor the changes you make next.

The red-green-blue colour alignment of the image can be seen using the 'RGB Align' tool. A small pop-up window should appear as that button is clicked. Now drag a box around your image of Mars by left-clicking and moving the mouse. Click the 'Estimate' button on the pop-up window and RGB should be aligned in the image.

Next, click the 'Histogram' button in the grid of buttons. Here you want to focus on the middle grey peak on the graph, but can't cut out the red, green and blue peaks. Usually this means dragging in the two ends of the graph and clicking the 'Stretch' button. This is when you should notice a significant improvement in contrast in your image preview. Don't worry if it doesn't look that much different at this stage, these are baby steps in processing that add up to the end result. You may notice that the blue, green and red peaks are all quite separated. To represent a view more like that which the human eye would see, we want to bring these colour peaks together. To do this, click the 'RGB Balance' button and in the new window click 'Auto balance'. This will inevitably take the vibrancy out of the image and also some of the contrasting detail. It is recommended here to emphasise the red channel a little bit to personal taste. The vibrancy can be further restored while retaining some colour accuracy by using the 'Colour Mixing' tool and increasing the saturation slightly.

Now for the final stage: move over to the left panel of the main window with all the sliders. This is the wavelets control panel. The principle is the same for each slider. Slide the sliders one at a time, each time

Main interface of RegiStax software including all options that can be adjusted and a preview of the final image of Mars for saving.

clicking a few ticks on the 'denoise' and 'sharpen' boxes above the slider. 'Denoise' will try to temper any enhancement of noise in the image, and 'sharpen' will offset some of the blurring present. Generally, the further down the list of wavelet sliders you go, the more drastic the changes are, so you may make a large change in the first slider and move the other sliders less and less as you move down through them. This may be a process you wish to revisit a few times to get the best image with the most detail available.

Once satisfied, the last thing to do is to save the image. You can choose to use the 'Resize Image' tool before this, to boost its resolution, but it may have a detrimental or unnatural effect on your final result.

The great thing about digital astrophotography is that you can revisit your original video files time and time again to try different techniques and amendments to create your ideal image of Mars.

If you move on to astronomical CCDs or start with them instead, the main difference will be the process of capturing the videos in the first place. This will involve using a computer with a program such as *Fire Capture* or *SharpCap*. Often these will already be in the correct video file format (AVI uncompressed), but it's still worth running the captures through *PIPP* to centre Mars in the frame. To obtain excellent results, a cooled greyscale CCD camera can be used with RGB colour filters and a high-power telescope on a tracking equatorial mount.

4: YOU, MARS AND THE FUTURE

There has never been a better time to explore Mars from the comfort of your own home. Spacecraft currently operating at and on Mars are constantly gathering images, and multimedia archives have been created for all previous missions. This data is available from mission image repositories, many of which are relatively easy for the general public to explore online. While it's interesting enough simply to browse, you can also help – there are a number of citizen science projects you can contribute towards to improve computer models and, in turn, our understanding of Mars. Finally, while it may seem like the stuff of science fiction, there are very real efforts to send humans to Mars in the not-so-distant future. This starts with practising what it would be like to live on Mars in simulated exploration missions in remote places on planet Earth. Anyone who wants to can have a part to play when it comes to exploring Mars.

Mars Archives

In order to make the most of image repositories online, a Mars global perspective is helpful for orientation. NASA's *Mars Trek* website is a good starting point, followed by the *Global CTX Mosaic of Mars* built by the Murray Lab at California Institute of Technology in the US.

On the home page of *Mars Trek*, you'll be greeted by a map of the entire planet and a pop-up offering a tutorial for the interface. After completing, or skipping, this you can click the globe icon in the bottom left and choose '3D Globe' to see Mars as a spherical projection. By clicking the top left Data icon, you can select 'Major Features' and scroll down to click the green 'Add' button to add that layer to the map. Orange labels for major features on Mars now appear on the globe. By clicking and dragging the globe you can find them all and zoom in. As you zoom closer, the lower-resolution and fuzzy imagery is replaced by higher-resolution images from eight different NASA and ESA Mars missions.

Screenshot of the starting interface for NASA's Mars Trek website.

To get a sense of scale, the menu on the right-hand side offers something called 'Country Mover', which gives the option of overlaying a country of your choice onto the surface of Mars. This can be dragged around the map onto features such as Olympus Mons or the polar icecaps to demonstrate the size of Mars and its features compared to familiar regions on Earth. Returning to a global map projection (flat) will allow other menu options, which are greyed out, to be selected. The menu offers some other interesting choices including the ability to measure distances, capture a screenshot of a region of Mars or even produce a file of a region that can be sent to a 3D printer.

To delve deeper into all features on Mars, the *Global CTX Mosaic* offers stunning high-resolution images of 99.5% of Mars as seen by the CTX (Context Camera) instrument on board NASA's *Mars Reconnaissance Orbiter*. Altogether the mosaic makes a 5.7 *terapixel* image of Mars – with a resolution about a million times higher than that of an image taken by a typical modern consumer digital camera. Each pixel on the mosaic is just five metres on Mars, therefore offering a resolution only bested by the landers and rovers that are taking pictures of their local area on the Martian surface. Once the page has loaded it can be helpful to select the 'Layers' icon in the top left of the window. From here, click the eye icon next to 'Feature Names (*IAU*)' to reveal the labels of all features in the area on screen. Depending on your zoom level, these labels may take several minutes to load. Shortcuts to Mars rovers are located at the bottom of the interface and clicking any of these will fly you to the area the rover operates or operated in, complete with a detailed track indicating where it has travelled. Another useful layer showing substantial features is the 'MOLA Topography' layer, which will display elevations and depressions in white and blue respectively from Mars Orbiter Laser Altimeter data.

Images from some of the robotic missions that have visited Mars can be explored via the NASA *Photojournal* archive, which

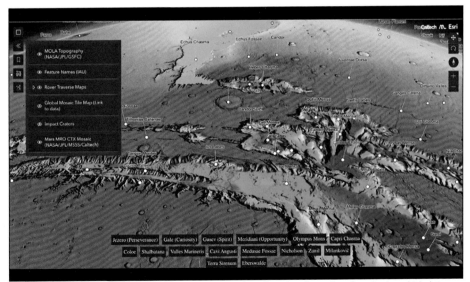

Screenshot of the interface for the Global CTX Mosaic *website featuring the options for selecting which data layers to show (top left of image).*

provides direct access to the highest-resolution versions of images they have captured. Once on the main page, click 'Mars' on the poster of the Solar System and from there you will be presented with five options with which to begin your search. All the images in the archive have an ID that starts with the letters 'PIA'. If you have the ID for a particular image from another website, which starts 'PIA', you can type in the number to go directly to that image's information and download page. It's more than likely that you'll make use of one of the other options. The first dropdown called 'Target' offers a choice of Mars or one of its moons, Phobos or Deimos. Clicking 'Select' for one of these will show images of the chosen target from all available instruments on all available spacecraft. The second dropdown offers a list of Mars missions, which may contain more than one spacecraft each (for example, a lander and an orbiter). The third dropdown offers a complete inventory of NASA spacecraft past and present from which to choose. Select a rover such as *Curiosity* or *Perseverance* to display images from the surface of Mars, and to view images from above Mars select an orbiter such as *2001 Mars Odyssey* or the *Mars Reconnaissance Orbiter*. Finally, the fourth dropdown offers a catalogue of specific scientific instruments if you wish to filter for a specific type of data.

Whichever option is chosen, the image list will provide some useful information at a glance, including the date the image was added to the archive, a thumbnail image and the resolution of the image. Clicking on the thumbnail will bring you to the original caption for the image and download links for either a Full-Res TIFF or Full-Res JPEG image. Many of these are suitable for printing or displaying on a large

Screenshot of the NASA Photojournal website showing the image results specifically for Mars and the Mars 2020 rover.

screen. If you're looking for moving media, clicking 'Animations' will bring up this type of multimedia, including GIFs and movie files. This does, however, filter for these types of media across all targets in NASA's database so you'll have to refine results by target, mission, spacecraft or instrument. Animations range from concept art depicting how water might have flowed in regions of Mars to clips of NASA's *Ingenuity* helicopter rising gracefully above the Martian surface.

Citizen Science

While browsing images of Mars can be fun and insightful, if you are interested in contributing to research that progresses our understanding of Mars, a citizen science project may be more to your liking. Citizen science projects are often created to analyse very large datasets. In the case of Mars, instruments on landers, rovers and orbiters generate enormous amounts of data that can take trained scientists decades to trawl through for key data that informs our understanding of the Red Planet's past and present. Often planetary scientists will use the latest in computer machine learning algorithms to crunch large amounts of data quickly. However, programs which auto-detect features need to be trained with good datasets, otherwise the result is inaccurate or, even worse, misleading. Large-scale citizen science projects invite the general public to use the innate human power of visual pattern recognition to seek out what scientists are looking for in a particular research area of interest. This could involve identifying complex terrain on Mars, interesting cloud formations, seasonal erosion features and much more. We'll take a look at some of the projects that you can participate in or review the results from, but the same principle applies across them all. Participants in these projects are given just enough information about the task they are being asked to complete. In this way it is purely a pattern-recognition exercise without skews towards

a particular hypothesis or favoured outcome that may bias results. Many of these projects have long lifetimes as an old dataset is used as a starting point, with further analysis of newer datasets added over time. These projects give participants a chance to be credited for their contributions in published scientific papers. Very occasionally, a citizen scientist may spot something that has never been seen before, which leads to a brand-new discovery. A great example of this is a rare astronomical object called Hanny's Voorwerp named after Dutch school-teacher Hanny van Arkel, who made the discovery as part of the Galaxy Zoo project.

Most importantly, in all these citizen science projects, each image is presented for analysis by more than one participant. For example, if nine out of ten people who view the same image agree on a particular classification and one does not, the single analysis can be considered an outlier and does not affect the average result. Equally, if there is a mix of classification results, the data can be revisited to see why it is so problematic to classify. Now let's look at a selection of Mars citizen science projects.

AI4MARS

In March 2013, when NASA's *Spirit* rover started dragging one of its wheels through the Martian surface rather than spinning, its days were numbered. If there had been a way for the rover to avoid problematic terrain automatically, it may have experienced an even longer mission run time. Improving hazard avoidance is the goal of the *AI4Mars* citizen science project started by a team at NASA's Jet Propulsion Laboratory. Most recent rovers are equipped with wide field of view cameras called hazcams (short for 'hazard avoidance cameras'). Their primary function is to display terrain in the immediate vicinity of the rover that mission control can monitor in order to avoid obstructions or unstable surfaces that may hinder or damage the robot. While

Screenshot of the interface for making classifications on the AI4Mars *citizen science project.*

these images can be manually monitored as incremental movements are made, this process can prove slow and difficult for the rover drivers on Earth, and it also leaves room for human error. The *AI4Mars* project team hopes that a terrain classifier can be built from the citizen scientist classifications of terrain. This involves creating a labelled dataset to train a machine learning model. Participants are asked to identify terrain types from hazcam images captured by *Curiosity* and *Perseverance* rovers. They can use a tutorial to understand how to identify and label each type of terrain.

Screenshot of the interface for making classifications on the Planet Four *citizen science project.*

The three terrain types are soil, sand and bedrock. Soil terrain is defined as compacted soil with small rocks that form a relatively firm surface overall. Sand terrain is characterised by fine sand, like that experienced on a sandy beach on Earth. Bedrock describes a surface covered in relatively flat rocks no more than 30 centimetres high. Users can also choose to label large rocks that appear rarely, although the scale of rocks can be deceptive, depending on the camera view. Generally, bedrock and soil are seen as relatively stable surfaces for rovers to traverse, while sandy surfaces should be avoided because of the risk of getting stuck.

While NASA's *Perseverance* rover can make some automated decisions on where it can and can't go, based on obvious hazards, a model built from this project's terrain analysis would offer more accurate hazard analysis, and safely accelerate the exploration of Mars for future rover missions.

PLANET FOUR
Named after Mars's position in the Solar System – counting from the Sun outwards – the *Planet Four* citizen science project concentrates on the south polar region of Mars. It aims to gather enough data to understand the seasonal variation of the climate in the region. The project uses images of sublimation features in this area, where frozen carbon dioxide transforms directly from a solid to a gas in the southern summertime. Frozen carbon dioxide that has sublimated into gas is trapped under thicker ice slabs, but heated by the sunlight that comes through the semi-transparent ice. This causes the gas to rapidly expand under pressure and burst out in the form of a geyser, taking with it dark basalt soil and spewing it onto the surface. In images from the HiRISE camera on board NASA's *Mars Reconnaissance Orbiter*, the features resemble what the project team refer to as 'fans' and 'blotches'.

When winds are present, the soil and rocks are spread out to form the fanlike feature and when there is an absence of wind the material falls within an elliptical radius of the exit point of the geyser to form a blotch. By inviting citizen scientists to analyse these images, the team behind *Planet Four* will have data to work out the seasonal regularity of these geysers (both time and location), as well as the strength and direction of the winds in the south polar region.

Contributing to the project involves pattern identification by eye with little need to understand precisely what the user is looking at. After a brief explanation of the project, users are presented with a random HiRISE image of the region and asked if there are seasonal fans and/or blotches visible in the image. If there are, you can click 'yes' and on the next section you can choose between marking fans or blotches. To mark a fan, you click and drag from what you feel is the origin point to draw out the length and direction of the feature. After releasing the mouse, you can click the points to adjust the spread of the fan to best match the dark shape you see in the image. If you need to mark blotches, a similar tool is available that draws out an ellipse when clicking and dragging and this can be similarly adjusted for the best fit. For each image you can choose 'Done & Talk' to enter the forum and chat about the image with other users and project team members. To create a useful dataset the project team catalogue uses a 0.5 cut-off for each image. If more than half of users identify features as fans, they are classed as such. If less than half identify features as fans for an image, they are classed as blotches instead.

The project coordinators have produced a scientific paper which verifies that the shape of fan features is not simply the result of the inherent angle of the geyser exit point, but the Martian winds. From here the data

Screenshot of the interface for making classifications on the Cloudspotting on Mars citizen science project.

gathered can be used to test various climate models for the planet and shed light on meteorological processes occurring at the south pole of Mars.

CLOUDSPOTTING ON MARS

This project is an example of research based on the unexpected. When NASA's *Mars Reconnaissance Orbiter* entered Mars orbit in 2006, it set to work capturing data including *infrared* images of the atmosphere as part of its Martian Climate Sounder (MCS) instrument. Very soon after receiving the first of these images, it was noted that strange loops were seen peeking above the lower atmosphere. The data allowed scientists to surmise that these were clouds at altitudes between 40 and 90 kilometres high. Referred to as mesospheric clouds, they are named after the part of the atmosphere that is present at that altitude – the *mesosphere*. These are dusty icy clouds and also occur on Earth but are known by a different name. Here, when seen from the ground looking up, they are referred to as *noctilucent* clouds. They are best seen at twilight and require specific low temperature

and pressure conditions. On Earth they are only visible from the northern hemisphere in the summer months and are, therefore, a rare treat for photographers in particular.

The *Cloudspotting* team wants to know exactly what these Martian clouds are made of and how they change seasonally. Considering that 95% of the atmosphere on Mars is compromised of carbon dioxide, the team also wants to understand how the 'dry ice' forms at such a great height. Since the MCS on the orbiter has been gathering data for many Mars years, there is a lot to process and, as with the other projects, far too much for a small team to handle without a properly trained machine learning algorithm to review and categorise the images.

Using a simple tool, users are asked to mark the peak of loops in the images, which is identifiable by the fact the feature will have two 'legs' and a noticeable high point in the middle. There is a selection of frames to study for each sample, and there are also colour inversion and zoom tools to better see these loops.

The project team hopes to continue its work with new datasets, covering other years with more or less dust present in the entire Mars atmosphere, and taken at different times of the day (the current dataset only covers 3 a.m. to 3 p.m. on Mars). Since the MCS camera gathers infrared light, it can see these clouds in the Martian nighttime as well as on its daylit side.

Humans on Mars

Throughout history humans have demonstrated an inherent need to explore; from the first to leave their local hunting ground, to those who crossed oceans for the first time, to the premier aeroplane flight by the Wright Brothers, to Gagarin's pioneering journey up through Earth's atmosphere. Many question the need to venture beyond Earth, given the capabilities of our far-reaching telescopes and robotic envoys. Yet nations around the world are planning to take humans tens of millions of kilometres across the void of space on a perilous six-to-eight-month-long voyage to land on a planet that so far shows no signs of being able to support life.

The scope and risk involved in a crewed Earth–Mars mission far exceeds that of a trip to the Moon and back, but the latter does provide some useful context. With our current technology, a voyage to the Moon takes approximately three days. The longest lunar mission yet completed, *Apollo 17*, lasted just twelve days. In that time the crew had plenty of supplies to last them their time there and back and didn't have to wait long to return to family and friends. While the mental and physical impacts of such a mission were not insignificant, they pale in comparison to not seeing another human being, besides crewmates, for two to three years, depending on the mission plan for getting to and from Mars. The crew also have to endure no natural day and night cycle, a reduction in tasting ability,

muscle wastage and bone-density loss over time. There are technological, logistical, physical and psychological problems to resolve before the green light is given for a human mission to Mars, not least the cost of launching a huge payload of astronauts, equipment, fuel and food supplies (which must be preserved to last), alongside the challenges of constructing a spacecraft to begin with. Before discussing how humans might try to live on Mars, the dangers involved in interplanetary space travel must be investigated.

Beyond Earth's atmosphere, astronauts on the International Space Station (ISS) are exposed to 250 times the radiation experienced on the surface of our home planet. This increases to 700 times the radiation for missions beyond Earth's orbit, which are without the protection of Earth's magnetic field. Astronauts spend months at a time on the ISS, while missions to the Moon subject crews to the higher levels of radiation but for a shorter period of days or weeks. By this measure, Mars missions would be by far the most damaging in that they combine long mission length and high radiation exposure. There are also instances during solar storms where energetic releases of radiation from the Sun (solar flares) bombard parts of our Solar System and can temporarily expose astronauts to far higher rates of radiation than those considered acceptable. Without adequate protection, members of a Mars mission crew have an increased risk of cancer and other degenerative diseases and, in the event of full exposure to a strong solar flare, could suffer the rapid onset of radiation sickness, which has a multitude of different symptoms.

In order to gain an understanding of the effects of the space environment on the human body, NASA and the ESA have been conducting long-term studies including one that followed twins Scott and Mark Kelly – Scott conducting lengthy missions on the

ISS, while Mark remained on Earth. This gave researchers a rare opportunity to compare two individuals with the same genetic make-up in two very different environments. The results showed that Scott's immune system reacted in the same way to vaccines in space as Mark's did on Earth. This means that vaccines that may need to be administered during a long mission in space should be just as effective. Researchers did see differences in Scott's gene expression and changes in telomeres compared to his twin on Earth. Gene expression is DNA's way of giving instructions to the body. Telomeres are the ends of DNA strands, and they protect *chromosomes* from damage. By studying how gene expression changed for Scott as part of the *Twins Study*, healthcare professionals could learn what aspects of treatments need to be modified or changed in order to tailor them to the immune system in space. Scott's telomeres lengthened in space over time compared to Mark's. While long telomeres were once thought to assist with a longer life span, it is now understood that at both extremes – short and long – they are detrimental to our health. Generally, short telomeres can negatively affect organs, while long telomeres increase the risk of cancer and other disorders. The *Twins Study* has provided NASA with an excellent baseline for targeted treatments and health plans for extended missions in space.

Astronaut twins Mark (left) and Scott (right) Kelly, participants in the NASA Twins study.

ESA has equipped some of its astronauts with radiation monitors to study in real time how much radiation they are exposed to. ESA has also partnered with institutes running physics experiments in Europe to bombard materials, including biological samples, with high-energy particles to observe the damage caused by cosmic rays and solar flares. By better understanding the impact of radiation, space agencies can start to mitigate exposure utilising new materials. In these tests, the metal lithium has proved to be a good form of shielding. While not yet tested, NASA has trialled the production of 'waste tiles' as a form of built-in radiation protection. Waste material would be baked, dehydrated and compacted to turn it into tiles as a potential viable radiation lining for the walls of a spacecraft. This process on the spacecraft would make use of existing payloads during the mission and could even include biological waste from the astronauts so that every gram counts. While this wouldn't be enough to line an entire spacecraft on the scale needed for the journey, a section of the ship could be reinforced, and the crew could temporarily retreat into it in the event of high solar activity.

Other technologies are being tested using specially manufactured materials such as in the 'AstroRad' vest, which uses a proprietary plastic made from *hydrocarbon polymers*.

Photograph of two mannequins fitted with special radiation protection vests and sensors as part of the Matroshka AstroRad Radiation Experiment (MARE) onboard the Artemis-1 mission around the Moon in 2022.

A first significant test of this radiation shield took place as part of NASA's uncrewed *Artemis-1* mission to the Moon in 2022. Two female mannequins were placed on board, each with over 5,000 sensors to detect radiation across many sections of the body. The female form was chosen as the female body is more sensitive to the effects of *ionising* radiation than the male body. One was equipped with an 'AstroRad' radiation vest while the other was left bare to demonstrate the level of protection that this equipment could provide. The data from the experiment showed that the Zohar mannequin (with vest) absorbed significantly less radiation than Helga (without vest). This data also helped to create a simulation that showed that Zohar would have absorbed 60% less X-ray radiation than Helga in the event of a strong solar storm. The vest has also been tested by astronauts on board the ISS.

To interrogate the psychological challenges of the long journey to the Red Planet, people from a variety of backgrounds have been put through simulated Mars missions, with each featuring some common elements including an artificial communication delay, isolation and limited resources. Participants in these missions are sometimes referred to as analogue astronauts as they play the part of an astronaut while not actually going to space. One of the most prominent of these studies was *Mars 500*, conducted in the Russian Academy of Sciences' Institute of Biomedical Problems, as a collaborative effort between Russian, European and Chinese space agencies. Over the course of 17 months, six analogue astronauts were placed in a simulated Mars mission environment, which included a spacecraft habitat for the simulated journey and an area that represented landing on Mars. For the first eight months, all six men lived together, but upon reaching 'Mars' three of the crew participated in the landing and

excursions phase. For a little over a week, they conducted Mars walks in realistically weighted spacesuits before rejoining the rest of the crew for the return leg home. By including a variety of nationalities, cultures and personalities, the simulated mission could be used to study team cohesion, conflict resolution, leadership, problem-solving and more. The results were generally very positive, with little friction caused by cultural differences and a natural inclination to be creative and celebrate milestones along the way, such as Halloween and Chinese New Year. However, maintaining a synchronised sleeping pattern proved problematic for some. With no natural sunlight – only artificial light and dark modes – some of the crew experienced disrupted sleeping patterns, which led to poorer performance in tests. The entire crew also generally slept more as the mission progressed, especially on the return part of the trip. They were subjected to tests that included emergency scenarios, power loss, communication issues and simulated crew sickness. Throughout the mission, they operated on a seven-day rota that incorporated two rest days. Their tasks included cleaning, maintenance, experiments, exercise and recreation. Just like a real space mission, they had a finite stock of food and water that had to be rationed out to last the full mission duration and their habitat was hermetically sealed. Post-mission, the participants underwent a battery of tests to see how their physical and mental health had been impacted by the experience in their 550 square metres of living quarters.

Other Mars simulations concentrate on what it would be like to live and survive on Mars for an extended duration. The *Hawaii Space Exploration Analog and Simulation* (*Hi-SEAS*) uses the slopes of Mauna Loa volcano to simulate the Martian landscape. Featuring a much larger environment as an analogue for Mars, it allows participants to take

Photograph of the habitat for the Hawaii Space Exploration Analog and Simulation (Hi-SEAS).

regular field trips to test tools, techniques and robots that could one day be used for real on Mars. Five NASA-funded *Hi-SEAS* missions have been completed by different crews, followed by a further set of missions funded by ESA under the acronym *EMMIHS* (*EuroMoonMars IMA Hi-SEAS*). The facility continues to be used to simulate non-Earth habitats in challenging conditions with one- or two-week missions open to applications from the general public. Applicants must pay a fee to participate and some relevant background knowledge is expected, though this is broad-ranging and dependent on what the researchers who oversee the operation are aiming to study on a particular occasion. The initial five *Hi-SEAS* missions produced baseline data for food systems, team cohesion and psychology on long-duration space missions.

Other environments have also been used to test the preparedness of astronauts for Mars travel. On Earth this includes Antarctic research stations, where day and night cycles differ greatly from permanently inhabited latitudes, while in space the ISS is particularly instructive with regards to the effects of *microgravity* on the human body. Combined with the development by

multiple space agencies and commercial space science and technology companies of larger spacecraft launch systems, the scene is set for landing humans on the Red Planet. If everything goes according to plan, a future crew will then have to deal with the harsh Mars environment. The first crew to travel to Mars is unlikely to land on the surface, but may deploy equipment and supplies for future, more ambitious, missions.

One concept involves building an orbital space station first before establishing any regular human presence on Mars. This could reduce the risks involved in getting crews onto and off the planet, at least initially. Astronauts on board a Mars space station could use remote-controlled robots, safely operated from orbit, to act as scouts for potential habitat locations. Astronauts on the ISS have already practised the techniques involved in this as part of ESA's *Meteron* project (*Multi-Purpose End-to-End Robotics Operations Network*). Once advance supplies and tools have been sent to a safe landing site the real work begins.

On Mars, just as on Earth, our basic requirements are breathable air, food, water, fuel and shelter. The robotic exploration of Mars has provided scientists and engineers the opportunity not only to analyse this alien environment, but also to test equipment that could prove useful as

Photograph of a lab technician in the clean room lowering the Mars Oxygen In-Situ Resource Utilization Experiment (MOXIE) instrument into the Mars Perseverance rover.

part of a permanent human settlement. Solar power has played a major factor in powering many previous robotic missions to Mars and is often cited as a potential energy source for a small habitat when appropriately scaled and cared for. Past experience has shown that although gentle, Martian dust storms coat solar panels in a layer of fine dust that lessens or completely obstructs power generation. As a result, they require regular cleaning.

Without a regular shipment of oxygen and water supplies from Earth, settlers on Mars will need to look to the local environment to extract what is needed. This is often referred to as 'in-situ resource utilisation'. One of the proposed technologies is to extract oxygen from the thin carbon dioxide atmosphere (the chemical name is CO_2, for the one carbon atom and two oxygen atoms contained within each molecule of the gas). NASA's *Perseverance* rover contains a small-scale demonstration of this technology, with its Mars Oxygen In-Situ Resource Utilization Experiment, or MOXIE for short. Although the device is not much larger than a lunchbox, it is able to convert carbon dioxide into oxygen at the same rate as one small tree on Earth. That equates to enough oxygen produced over two years for a human to survive just 3.5 hours. While this is hardly enough to provide for a small settlement, it is only operating on about 100 watts of power – available through *Perseverance*'s main power system. With a much greater power source capable of generating tens of thousands of watts, a small habitat could be supported.

Water can be found on Mars but in the form of ice, and in most exposed surface areas it is not present. It has been detected at the polar icecaps but, even then, it is locked away under thick slabs of frozen carbon dioxide. Water ice could be preserved and accessed in deep craters, in caves and in partially collapsed lava tubes where sunlight does not reach. NASA's *Phoenix* lander literally dug up evidence of water ice just beneath the surface of the planet, but this was in a polar region that is not favoured for human settlement. Compounding matters is the fact that water detected thus far on Mars has a high concentration of *perchlorate* salts that are toxic to humans – a filtration process or, potentially, use of a hardy strain of bacteria would be required to detoxify the supply. Many chemical processes that produce viable fuel for rockets also produce water so humans may not have to risk life and limb or precious tools to extract liquid water directly from water ice on Mars. Water is known chemically as H_2O – two hydrogen atoms with one oxygen atom. Therefore, it is often described as a useful combination of rocket fuel (hydrogen) and oxygen. Using electrolysis, the process by which electricity is used to separate the hydrogen and oxygen atoms, it is possible for water to provide both fuel and breathable air, although the aforementioned perchlorates, the extremely low temperatures Mars reaches and its lower gravity significantly reduce the efficiency of the process.

In terms of food requirements, experiments are under way on board the ISS and on Earth to grow crops under LED lights, both with hydroponic techniques and in simulated Mars soil. Hydroponics involves keeping plants rooted in nutrient-enriched water and, thanks to data gathered by generations of landers and rovers, scientists on Earth can create soil mixes that approximate to Mars chemically and structurally. 'Soil' is a slightly misleading term for the substance on Mars, which is better defined as 'regolith' – inorganic dust and broken-up rock. Some areas of the surface and subsurface contain clays and basalt (cooled lava), and there is a strong mineral presence including iron oxides – commonly known as rust – which give Mars its iconic hue. While this is hardly what can be described as 'rich soil', it is the basic foundation for a medium in which plant life could be grown.

Photograph taken outside the International Space Station showing the BIOMEX experiment compartments, one of which contained dried cyanobacteria in a Mars soil simulation for later DNA analysis back on Earth.

The ability to produce water would bring us a step closer to food production, but we need some organic material in the mix too. Studies of *cyanobacteria*, also called blue-green algae, have shown that it can grow with limited resources. On Earth, it is often seen as a natural menace due to its fast-spreading nature. On the ISS, as part of BIOMEX (BIOlogy and Mars EXperiment), organic samples were placed outside the space station, exposing them to the extreme environment of space. Simulating the Martian environment, samples that had cyanobacteria mixed in a Mars soil simulant under a filter that blocked some harmful radiation, survived. Samples that were not

mixed with the soil and were also exposed to a full spectrum of radiation died, the samples that were set up in a replicated Mars environment survived for over 700 days in space. Although their DNA was damaged, they were found to repair themselves after rehydration on Earth. Based on these results and other lab simulations, a strong or modified strain of this algae could be used to enrich the Martian soil in order to grow edible vegetables on the Red Planet.

Other experiments have highlighted the benefit of hydroponics to enable vertical farming. By housing racks of edible greenery in the spacecraft that would take humans to

Mars, the contents for a Mars greenhouse would be ready to move onto the surface upon arrival. Water, however, is a precious commodity and heavy in great quantities. Aeroponics takes the process of soilless gardening a step further by suspending plants and their roots in mid-air and regularly exposing them to a nutrient mist. This makes efficient use of water en route to Mars, as well as significantly reducing the initial launch payload from Earth. In many ways this form of food cultivation sidesteps significant issues such as the spread of plant diseases and the acidity of soil. One disadvantage is that the misting needs to be carefully monitored and the content of the mist needs to be precisely formulated. Failure in either regard could lead to a disastrous loss of crops. At the very least, this form of farming could kick-start the food supply on Mars on arrival until enough algae and compostable waste is accumulated to switch to more traditional soil-based farming methods.

There are a number of options for generating fuel that combine some supplies brought from Earth and the chemistry available on Mars. One technique was discovered back in the late 19th century, when life on Mars was the hot topic of the day. Called the Sabatier reaction, named after its discoverer Paul Sabatier, it involves cooking a combination of hydrogen and carbon dioxide at high temperatures (over 300°C) to produce methane and water. Liquid methane is a viable form of rocket fuel and the water from the Sabatier process could also contribute to that need for the habitat. The water production process has already been tested on the ISS, and despite some repeated technical difficulties, it demonstrated that the only new element required to keep the process going was a fresh supply of hydrogen. Transporting a large hydrogen supply to Mars is an extremely lightweight option and both the atmosphere and ice on Mars are abundant in carbon dioxide. Any

methane produced in the ISS experiment was jettisoned, as it wasn't needed, however on Mars it would prove invaluable as a propellant. As with the MOXIE device, this process requires substantial daily energy production to produce useful quantities of methane for fuel, but it is an energy-efficient process. An advantage to refuelling a spacecraft on Mars for a return journey to Earth is that the planet has only 38% the gravity on Earth, requiring far less fuel to reach Mars's orbit.

Any technology that incorporates in-situ resource utilisation on a Mars base will be able to take advantage of decades of innovation on spacecraft like the ISS. This includes the systems that already recycle the air astronauts breathe, extract the water in their waste and the electrolysis method of separating water into oxygen and hydrogen. Finding an efficient way of using the resources on Mars will rely on repeated experimentation on the ISS and in simulation labs on Earth. The key will be to find the right combination of technologies from those experiments that require as few imported resources from Earth as possible.

While air, food and water could sustain a habitat on Mars, such resources are wasted if these explorers are exposed to the harsh radiation present on the surface of Mars. The Radiation Assessment Detector (RAD) instrument on NASA's *Curiosity* rover detected radiation equivalent to a third of what would be experienced on the way to Mars. However, it is not expected that astronauts would be exposed to this maximum radiation at all times, spending periods inside shielded habitats. As with everything else on the essentials list, building shelters on the planet needs to make use of the in-situ resources to avoid enormous payloads.

Suggestions for viable living quarters on both the Moon and Mars begin with the

Photograph showing the entirely 3D-printed Mars habitat simulation, part of NASA's CHAPEA experiment on Earth.

design and construction of a reinforced inflatable habitat that can be covered with a protective shell constructed from a form of concrete that makes use of the regolith in the region. As an example, University of Manchester researchers have developed a type of concrete they've named 'StarCrete' that mixes starch and Mars soil simulant and is twice as strong as typical concrete on Earth. While it doesn't use this material, a Mars habitat was 3D-printed as part of NASA's Crew Health and Performance Exploration Analog (CHAPEA) at the Johnson Space Centre, Florida. This could help inform a future base printed on Mars. Any of these options must also take into account

the extreme temperature changes. Even the most ideal region of Mars in this regard, the equator, still experiences a huge swing from daytime highs of 20°C to nighttime lows of -73°C at the height of summer. We may need to turn to our sustainable technologies on Earth, such as designs for passive houses, to select insulation technologies that minimise the power needed to heat Martian habitats. If these structures constructed from scratch are insufficient, Mars does offer a few natural alternatives in the form of caves and lava tubes for natural radiation protection, though their structural integrity would need extensive testing and verification.

Living on Mars may be the greatest challenge yet tackled by humankind in our quest to continue exploration beyond our safe haven on Earth. Take a moment to think of the first pilots to trust in science and engineering to see them safely over the great expanse of the Atlantic Ocean. Once thought of as folly or fantasy, the journey is now taken by tens of millions of passengers each year. When a trip to Mars becomes a regular occurrence, who knows what humankind can achieve? This could include attempts to terraform Mars and in doing so discover techniques that could be applied to repair environmental damage on Earth.

With this thought we can also consider what we could do differently on another world. By starting without country boundaries and with a spirit of collaboration, we may discover innovative ways of living and working together that benefit humankind and our environment on Earth just as much as on our home away from home. The foundations have been laid by the dreams of centuries of scientists and science-fiction authors, the telescopic exploration of Mars from afar and gigabytes of data collected by our robotic explorers in more recent times. While we don't know when exactly someone will make that first footprint on the Red Planet, it seems excitingly inevitable.

'I think Mars is a stepping stone for humanity on the way to becoming a multiplanetary species.'

Andy Weir, author of *The Martian*

Sunset on Mars, captured by NASA's Spirit rover on May 19th 2005.

5: MARS RESOURCES

Information on all present and past robotic missions to Mars from The Planetary Society:
https://www.planetary.org/space-missions/every-mars-mission

High-resolution atlas images of every section of Mars from the USGS Astrogeology Science Center:
https://planetarynames.wr.usgs.gov/Page/mars1to5mTHEMIS

FREE PLANETARIUM SOFTWARE TO PLAN OBSERVATION AND PHOTOGRAPHY OF MARS:
https://stellarium-web.org/ (web interface)

https://stellarium.org/ (software download)

FREE MARS DIGITAL PHOTOGRAPHY PROCESSING TOOLS:
PIPP – https://pipp.software.informer.com/

AutoStakkert! – https://www.autostakkert.com/

RegiStax – https://www.astronomie.be/registax/

MARS IMAGE REPOSITORIES:
NASA Mars Trek – https://trek.nasa.gov/mars/

Global CTX Mosaic of Mars – https://murray-lab.caltech.edu/CTX/V01/SceneView/MurrayLabCTXmosaic.html

NASA Photojournal – https://photojournal.jpl.nasa.gov/

MARS CITIZEN SCIENCE PROJECTS:
AI4Mars – https://www.zooniverse.org/projects/hiro-ono/ai4mars

Planet Four – https://www.zooniverse.org/projects/mschwamb/planet-four

Cloudspotting on Mars – https://www.zooniverse.org/projects/marek-slipski/cloudspotting-on-mars

Glossary of Terms

Asterism A highly recognisable pattern of stars that is not a defined constellation

Caldera The top of a volcano that has collapsed in on itself after eruption

Carbonate An ionic compound that is a salt of carbonic acid

CCD Stands for Charged Coupled Device and is the electronic chip found in all digital cameras that captures light and transmits it as an electrical signal to create a digital image

Chromosome A package of DNA that carries genes

Cosmic Radiation High-energy-charged particles that move at almost the speed of light from the most volatile events in the Universe such as exploding stars

Cyanobacteria Hardy microscopic organisms that survive through photosynthesis

Dacite Volcanic rock from fast-cooling lava

Digital Noise Fluctuations in electrical signal from a camera chip that show as a nuisance grain effect on digital images

DSLR A type of digital camera, it stands for Digital Single-Lens Reflex – where reflex indicates that a mirror is used to reflect the camera view to the user

Exposure The length of time a piece of film or CCD is open to light

Focus In terms of geometry, it is the centre of a circle or, in the case of an ellipse, foci are the two internal points that determine how elliptical an ellipse is

Frost Evaporation The process of ice sublimating, see 'Sublimation'

Gypsum A soft mineral with the chemical name calcium sulfate dihydrate

Hematite A common iron oxide compound

Hydrocarbon Polymers Large molecules of bonded hydrogen and carbon atoms

Hydrothermal Water heated by a planet's internal heat at the crust

IAU Stands for International Astronomical Union, responsible for astronomical definitions, including, but not limited to, naming astronomical bodies

Inert Chemically inactive

Infrared A form of electromagnetic radiation just beyond the visible part of the light spectrum, lower energy

Ionising The process of removing one or more electrons from an atom

ISO A measure of light sensitivity for physical photographic film or light sensitivity setting for a CCD

Latitude The distance north or south of the equator, measured in degrees

Longitude The distance east or west of the Greenwich meridian, measured in degrees

Magma Molten rock that can exist beneath the crust of a planet when temperatures are high enough

Mantle Plume	Rising molten material that is less dense than surrounding material and therefore floats upwards
Mesosphere	For Mars, this is the section of atmosphere that is 40 to 100 kilometres above its surface
Meteorite	A space rock that has reached the surface of a planet, moon or other solid body
Meteoroid	A small space rock that has not passed through an atmosphere or landed on a body
Meteorology	The study of weather systems and other dynamics in atmospheres
Microgravity	An environment where the effects of gravity are barely felt
Morphology	The study of structures and shapes
Noctilucent Clouds	High-altitude clouds of dust and ice crystals that seem to shine seasonally in sunlight
Opposition	When a planet or astronomical body is in the opposite position in the sky to the Sun, usually the best time to view a planet, for example
Perchlorate Salt	An inorganic compound of oxygen and chlorine that is toxic
Pumice	Volcanic rock from fast-cooling lava that is highly porous
Quantum Microscope	A microscope that takes advantage of quantum effects to visual incredibly small objects rather than using magnified light
Radioactive Decay	Reduction of radiation from unstable atoms through the release of radiation over time
Radioisotope Generator	Uses radioactive decay to generate an electrical current by moving electrons from hot to cold side of components in the generator
Recurring Slope Lineae	Seasonally appearing and disappearing linear dark streaks on the surface of Mars
Shield Volcano	A broad type of volcano with gently sloping sides
Silicates	Minerals that contain both silicon and oxygen
Solar Wind	The continuous stream of charged particles that escapes the Sun's atmosphere in all directions
Sublimation	When a solid turns directly into a gas
Tectonic	Relating to large-scale changes in the structure of a planet's crust
Telegraph	Early form of electrical communication by transmitting electrical signals on and off via wires over long distances
Terapixel	1 trillion pixels (1 with twelve zeros after it)
Topography	The study of natural or artificial surfaces
Ultraviolet	A form of electromagnetic radiation just beyond the visible part of the light spectrum, higher energy

Acknowledgments

5	The Picture Art Collection / Alamy Stock Photo	
6	© Marie-Lan Nguyen / Wikimedia Commons	
7	Icelandic National Library	
8	Gordon MacGilp	
10	Skokloster Castle/SHM (PDM)	
11	Kepler-Museum Weil der Stadt	
12	© MikeRun / Wikimedia Commons	
14	ETH-BIBLIOTEK ZURICH / SCIENCE PHOTO LIBRARY	
15 *top*	Science History Images / Alamy Stock Photo	
15 *bottom*	Gordon MacGilp; Shutterstock / ezsolee	
17	Bettmann / Getty Images	
18	SCIENCE SOURCE / SCIENCE PHOTO LIBRARY	
19	Harvard Plate Stacks, Center for Astrophysics	Harvard & Smithsonian
21	© National Maritime Museum, Greenwich, London	
23	Henrique Alvim Corrêa / Wikimedia Commons	
24	NASA/Jet Propulsion Laboratory-Caltech	
25	DETLEV VAN RAVENSWAAY / SCIENCE PHOTO LIBRARY	
26	NASA/JPL	
27	NASA/JPL	
28	All Rights Reserved Beagle 2	
29	NASA/JPL-Caltech/Cornell	
30	NASA/JPL-Caltech/University of Arizona	
31	NASA/JPL-Caltech	
32	© Indian Space Research Organisation / Wikimedia Commons	
33	NASA/JPL-Caltech	
34	Emirates Mars Mission / EXI / Jason Major	
35	© 中国新闻网 / Wikimedia Commons	
36	NASA/JPL-Caltech/MSSS	
38	NASA	
39	Encyclopædia Britannica, Inc.	
40	NASA/JPL-Caltech	
41	ESA	
42	ESO/L. Calçada	
44	DAVID DUCROS / SCIENCE PHOTO LIBRARY	
45	NASA	
46	ESA/DLR/FU Berlin (G. Neukum)	
47	ESO/M. Kornmesser/N. Risinger (skysurvey.org)	
48–49	ESA/DLR/FU Berlin (G. Neukum)	
50 *top*	ESA/DLR/FU Berlin	
50 *bottom*	ESA/DLR/FU Berlin; NASA MGS MOLA Science Team	
52 *top*	NASA/Goddard Space Flight Center Scientific Visualization Studio	
52 *bottom*	MOLA Science Team	
54 *top*	ESA/DLR/FU Berlin (G. Neukum)	

54 *bottom*	NASA/JPL/USGS
55	MOLA Science Team
56-57	ESA/DLR/FU Berlin (G. Neukum)
58–59	ESA/DLR/FU Berlin, CC BY-SA 3.0 IGO
60	ESA/DLR/FU Berlin
61	NASA
63	ESA/DLR/FU Berlin
64–65	NASA/JPL-Caltech/University of Arizon
66–67	NASA
68	ESA/DLR/FU Berlin (G. Neukum)
69	NASA / JPL-Caltech / MSSS
71	Shutterstock / Josep.Ng
72	SkyChart / Cartes du Ciel
76	OpenStax / Wikimedia Commons
77 *left*	Shutterstock / Shutterstock-Pixelsquid
77 *right*	Szőcs Tamás Tamasflex / Wikimedia Commons
80 *top left*	Cartes du Ciel/ NASA/ JPL
80 *top right*	Cartes du Ciel/ NASA/ JPL
80 *bottom left*	Cartes du Ciel/ NASA/ JPL
80 *bottom right*	Cartes du Ciel/ NASA/ JPL
83	Pete Lawrence
84	PIPP Manual
85 *top*	© Roger Hutchinson
85 *bottom*	© Roger Hutchinson
87	Registax
88	NASA
89	Global CTX Mosaic
90	NASA
92 *top*	AI4Mars / Zooniverse
92 *bottom*	Planet Four / Zooniverse
94	Cloudspotting on Mars / Zooniverse
96	NASA
97	NASA/Frank Michaux
99	Michaela Musilova/ HI-SEAS
100	NASA
102	NASA
104	NASA
106	NASA

Specialist editorial support was provided by Ed Bloomer, Senior Astronomy Manager: Digital & Data, and Patricia Skelton, Deputy Head of Astronomy Engagement at Royal Observatory Greenwich, part of Royal Museums Greenwich.

The author would also like to thank Joshua Nall, the Director of the Whipple Museum of the History of Science, University of Cambridge for his invaluable knowledge on the history of the Mars canal saga.

Author Biography

Brendan holds a BSc in Physics and Astronomy and an MSc in Science Communication, both earned from Dublin City University. With a rich professional journey spanning a decade at Royal Observatory Greenwich, he has dedicated himself to igniting curiosity through various public and school engagement projects, focusing on a diverse array of themes within astronomy and space science.

Throughout his career, Brendan has collaborated with community groups, schools, and informal learning organizations, as well as the broader public, delving into the intricacies of the Universe. His passion extends beyond astronomical exploration, encompassing themes such as breaking down stereotypes, promoting empowerment through lived experiences, and examining the vital role of science in society.

A pivotal phase of his career involved contributing to European Commission projects at the Science Gallery, Trinity College Dublin. Currently, Brendan currently works at the Institute of Physics, where he actively supports current and emerging physicists in public engagement, striving to cultivate a more inclusive physics community.

Brendan maintains a strong connection with Royal Observatory Greenwich, serving as an Astronomer Emeritus there. He remains a passionate stargazer, beginner astrophotographer and avid supporter of dark skies worldwide.